CARRIE MAE WEEMS

THE LOUISIANA PROJECT

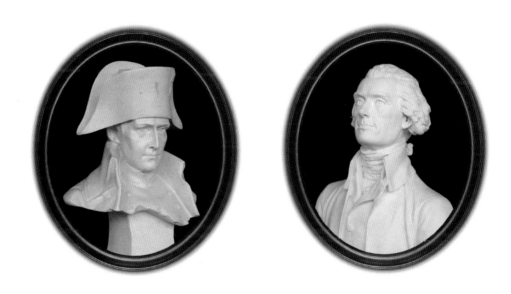

NEWCOMB ART GALLERY TULANE UNIVERSITY

THE EXHIBITION

Newcomb Art Gallery, Tulane University, New Orleans	*October 9–December 14, 2003*
Spelman College Museum of Fine Art, Atlanta	*July 15–September 25, 2004*
The Hyde Collection, Glen Falls, N.Y.	*February 6–April 10, 2005*
DePaul University Art Gallery, Chicago	*July 15–September 2, 2005*
Samek Art Gallery, Bucknell University, Lewisburg, Pa.	*October 14–November 30, 2005*
Polk Museum of Art, Lakeland, Fla.	*December 10, 2005–February 12, 2006*

Traveled under the auspices of Pamela Auchincloss/Arts Management.

CONTACT INFORMATION

Newcomb Art Gallery, Tulane University, New Orleans, LA 70118
Telephone: 504-865-5328 Facsimile: 504-865-5329
E-mail: gallery@tulane.edu Website: newcombartgallery.com

ISBN 0-9668595-4-5

CONTENTS

FOREWORD 5 *Erik H. Neil*

CARRIE MAE WEEMS: REFLECTING LOUISIANA 7 *Susan Cahan*

LOUISIANA LEGALITIES IN BLACK AND WHITE 17 *Pamela R. Metzger*

THE LOUISIANA PROJECT 25 *Carrie Mae Weems*

EXHIBITION CHECKLIST 74

ILLUSTRATIONS 75

ACKNOWLEDGMENTS 76

THE PURCHASE

Who could have known the consequences of the exacting hands

of fate in the theater of history: the roles of geography,

climate, disease, forces outside the power and control of men;

who could have planned the contingencies or the consequences?

Though rarely discussed, it is known that the Louisiana Purchase

was not so much the result of skilled negotiations on the parts

of Monroe and Jefferson, but the consequences of Saint Dominique

{Haiti}, malaria, yellow fever, and the spreading seeds of

freedom in the mind of Toussaint L'Ouverture.

FOREWORD

Erik H. Neil

ISTORICAL commemoration can be a tricky thing. Selections must be made regarding just what and who will be recognized. Inevitably some aspects or people will be left out of the story. The celebrations surrounding the Bicentennial of the Louisiana Purchase have been no different.

In New Orleans, leading cultural institutions planned events commemorating the Louisiana Purchase. The New Orleans Museum of Art and the Historic New Orleans Collection presented important exhibitions on the art of France and America in the era of Jefferson and Napoleon and Louisiana's cartographic history. At Tulane University, faculty members met to consider how our individual departments might participate in the remembrance. Given that other museums were handling broad, artifact-based exhibitions, I felt that the Newcomb Art Gallery had more freedom to take a critical or polemical look at the legacy of the Louisiana Purchase and that a contemporary interpretation would be suitable and practical.

Almost immediately my thoughts turned to the artist Carrie Mae Weems and her piece *The Jefferson Suite*. Her work is striking for the evident appreciation of history's complexity and her willingness to challenge the conventional account. With regard to Thomas Jefferson, she appreciates his ideals *and* his humanity. She recognizes his weaknesses, especially in relation to Sally Hemings, but she would not have us abandon Jeffersonian concepts of freedom and justice. Weems affirms that a consideration of the past helps us to understand the present.

From an inquiry about *The Jefferson Suite*, I learned that Weems had long been interested in New Orleans, and the idea of a new work, *The Louisiana Project,* was born.

A constellation of issues, Social Justice, Racial Identity, Sexual Identity, and Slavery's Legacy, interlace to form the texture of the work. These are critical issues for contemporary American culture, and Weems focuses on them through the lens of New Orleans and Louisiana history. Weems alternately serves as a witness, an actor, an interlocutor. We are asked to reflect on our attitudes and the roles that we play. Through the Louisiana Purchase, varied cultures—Anglo-American, Franco-Caribbean, and African—were thrown together in a new way. One result of the mingling of peoples was the forging of a complicated racial and social hierarchy, a sort of love triangle, involving white men, their wives, and their "Creole" mistresses. Class, race, and sexuality—charged and modern concepts—are the latticework that shape *The Louisiana Project*.

This publication includes two valuable essays. Susan Cahan places *The Louisiana Project* within the framework of Weems' career, exploring the artist's methods and objectives. Pamela Metzger, whose essay grew out of the symposium, "The Mirror and the Mask, Race and Identity in New Orleans and Beyond," held in conjunction with *The Louisiana Project*, gives insight into the legal paradoxes and obsessions in the construction of racial identity in Louisiana. Together the essays fittingly complement the powerful images of Carrie Mae Weems.

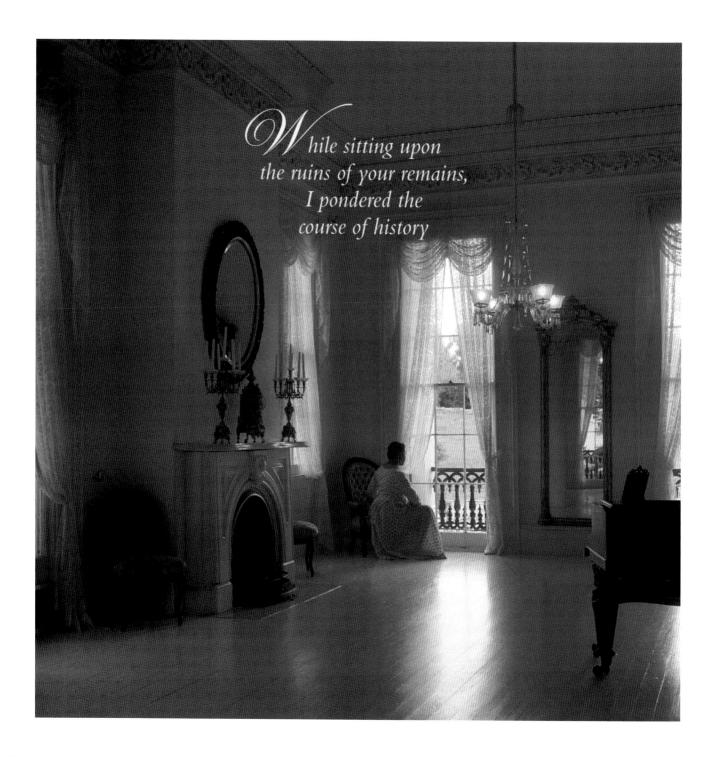

While sitting upon the ruins of your remains, I pondered the course of history

CARRIE MAE WEEMS: REFLECTING LOUISIANA

By Susan Cahan

ᴄARRIE MAE WEEMS' *The Louisiana Project* (2003) was inspired by a unique New Orleans ritual in which the city's wealthiest and most elite citizens step out of their ordinary lives to impersonate royalty. Weems was invited by the Newcomb Art Gallery to create a new work as part of a citywide commemoration of the Bicentennial of the Louisiana Purchase—the deal made between Thomas Jefferson and Napoleon giving the United States a vast swath of land stretching from Louisiana to the Rocky Mountains. Most of the exhibitions commemorating the event were celebratory in nature. By contrast, Weems took a more critical look. Rather than focus on the great deeds of great men, *The Louisiana Project* is a poetic meditation on the lives of ordinary people using the Louisiana Purchase as a springboard to explore how the city's unique public culture preserves social hierarchies handed down from antebellum times. The result is a series of images that are as beautiful as they are jarring. The power of their impact is, in part, a result of their simplicity. Weems looked closely at the city of New Orleans and shows us just what she saw, a racially divided place with sharp disparities between rich and poor, and a culture that desperately clutches the customs of the past through ceremony, masking, and the maintenance of façades.

As is typical of her working process, Weems did volumes of research about Louisiana and its magnificent, imperious history starting in the late eighteenth century when the area belonged to France and was Napoleon's foothold in North America. Situated on the Mississippi River, near the Gulf of Mexico, New Orleans provided the French with easy access to colonies in the Caribbean and trade routes in North America. New Orleans was such a desirable site that the French, Spanish, British, and Americans all vied to control it. Its settlement by different groups and its involvement with slavery and colonialism led to an extraordinary cultural and ethnic mix, influenced not only by various European cultures, but also by those of Africa, Haiti, and indigenous America. Weems studied the rivalries that took place among the French, Spanish, and English and the ignominious circumstances that led Napoleon to sell the Louisiana Territories to the United States. Finally, Weems settled on her point of entry into her subject: the unique way in which Mardi Gras is celebrated in New Orleans.

Mardi Gras (or "Fat Tuesday") is the culmination of Carnival, the period of feasting and celebration that begins on Twelfth Night, or Epiphany, and ends at midnight on Shrove Tuesday. This period of indulgence is supposed to leave the faithful in good

shape to face the self-denying rules of Lent. According to most sources,[1] Carnival began in New Orleans in the late eighteenth century, but it wasn't until the mid nineteenth century, with the founding of groups that came to be known as "krewes," that the celebration became a way of inculcating social hierarchies. It is the krewes that stage the annual parades through the streets of New Orleans as a prelude to Lent. Today, there are about thirty krewes that take to the streets each year. The earliest and by far most prestigious "old-line" krewes are Comus, Momus, and Rex. Comus was founded in 1857, and Momus and Rex in 1872. Membership in these organizations is by invitation only, and, despite recent battles to eliminate discriminatory practices, participation is strictly controlled by an "old-boy" network. Each year one of the wealthy and powerful members of the Rex organization is secretly chosen to be "Rex," King of Carnival (or "Monarch of Merriment," as he is sometimes called). Rex receives the highest honor of all: He presides over the Rex

parade, accompanied by his masked captain and a host of masked lieutenants, and, in a custom inherited from the nineteenth century, reigns over the city as the mayor whimsically turns all his powers over to Rex for the day.

To those who live in New Orleans, the unique local rituals of Mardi Gras are a focal point of civic life. Not only do hordes of citizens take to the streets to either parade or cheer from the sidelines, thousands of tourists flock to the city making it one of the most important and lucrative events of the year. To an outsider, someone not raised in New Orleans, and particularly not from the South, the rituals of Mardi Gras can seem strange—at best a childish world of make-believe, at worst a public celebration of antebellum values cloaked in a masquerade of pomp and circumstance. According to writer James Gill, "In New Orleans, Mardi Gras is a year-round obsession for many people and inspires the fervor of a pagan religion. Much of the city's social intercourse centers on krewe

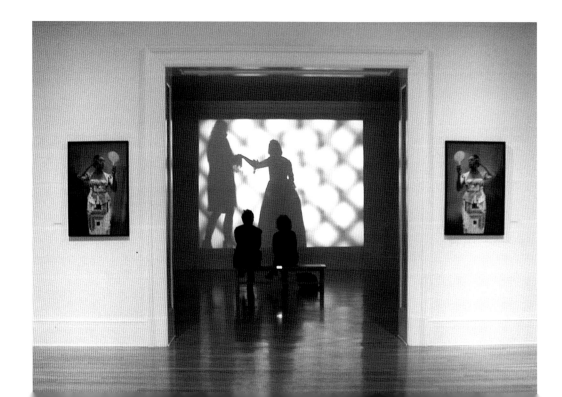

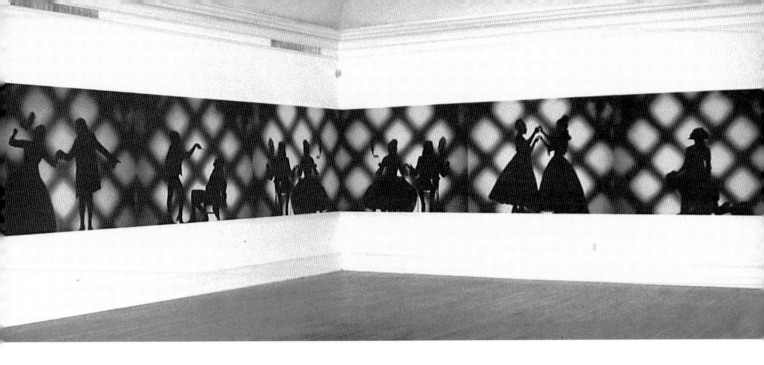

get-togethers and the endless planning for the next parade. Mardi Gras is a major industry, and helps define the subtle gradations of the city's social and racial caste system."[2] Today, the parades include recent innovations, as well as practices that have been retained for more than 100 years. The hoi polloi on the streets brazenly raise their shirts or drop their pants in order to entice parade riders to toss "throws." Meanwhile, in exclusive clubs and hotels, old-line krewes cap Mardi Gras revelry with closed debutante balls attended by invitation only. Dressed in formal gowns, debutantes, whose social grooming began as children, are formally introduced into society during a night of dining and dancing. Most revelers on the street are scarcely aware that Carnival balls— rituals devised in antebellum times to celebrate the closed world of the upper class—occur.

Fascinated by these Carnival rituals and the meanings of masking and masquerade, Carrie Mae Weems created a work that is as complex as New Orleans itself. *The Louisiana Project* is comprised of photographs, a video projection, and a series of

laser prints on canvas, all choreographed to present a portrait of New Orleans that situates the present city within its complicated past. The first gallery introduces the overall themes of the work. One encounters two oval photographs of busts of Jefferson and Napoleon, the two main actors in the Louisiana Purchase. Near these images are photos of Weems. In one she wears a donkey mask, in the other the mask of an elephant, carnivalesque versions of a Democrat and a Republican. In a nearby suite of four photographs, individuals regard themselves intently in handheld mirrors against stark black backgrounds, spaces in which to project fantasies, dreams, and nightmares. Weems sits next to each figure, sometimes holding the mirror, like a spirit, muse, or perhaps, a conscience. The piece as a whole is replete with mirrors and reflected images as if to ask, how do you perceive yourself? How do others perceive you? Flanking a doorway are images of Weems herself standing like a sentinel in a calico patchwork dress contemplating her own image in a handheld mirror.

Beyond this door is a salon-like room containing

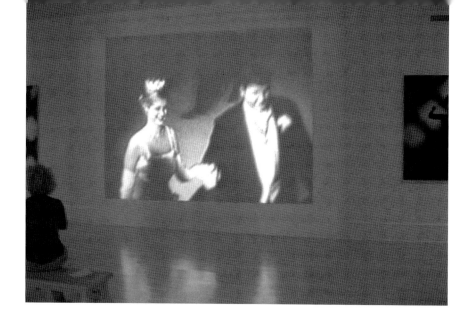

mural-size images of Rex and his Queen, the Mardi Gras figures of highest rank. The seated couple is depicted in shadow along with a range of other images, including two dancing women in formal dress, a woman curtseying to a man, a man bowing to a woman, a servant passing by unnoticed, and a female dominatrix who appears to be Weems herself "working over" a gentleman in uniform. The silhouetted figures are seen against a diamond-patterned grid that resembles a chain-link fence. Are we outsiders eyeing these figures through this fence-like structure? Or is it the figures themselves who are trapped within this grid? As art historian Rosalind Krauss has pointed out, the grid is a pattern that extends outward in all directions compelling our acknowledgment of the world beyond the frame.[3] The artwork that incorporates the grid exists as a fragment of an ostensibly infinite space, the real space that we, as viewers, occupy.

The grid is also a matrix that helps us see spatial relationships by providing a uniformly divided field, in which objects can be plotted, locations understood, and positions mapped. However, searching for such precision in Weems' shadow play is an exercise doomed to end in frustration as the ambiguity of the shadows thwarts clear identifications. Laser-printed in silhouette, it is difficult to tell who is of one race and who of another, who is white, black, or one of the innumerable permutations identified by names like octoroon or quadroon. There is a tension between clarity and doubt. Says Weems, "I thought it would be much more interesting to be able to pull back and to simply see these [interactions] in a shadow play where all the gestures are there but you don't necessarily know who is in it."[4]

The centerpiece of this room is a video projection reiterating some of the images in the murals and containing television footage of a Rex Mardi Gras ball with the so-called "meeting of the courts" of Rex and Comus and the introduction of the debutantes. The footage of the ball has an eerie, old-fashioned feel. Weems shot the telecast of the ball with a super 8 camera so that not only does the subject matter seem dated, but the image quality also looks old-fashioned. But lest one think this dress-up event is only a vestige from the past, think again. The images displayed are of recent vintage—from 2003.

At the debutante balls of Mardi Gras, the elite are introduced year after year into a social order

that verifies their claim and authority of the city. As images float across the screen, the sound of Weems' deep, mellifluous voice fills the gallery space, deconstructing the role of the old-line krewes. She speaks directly to the aristocracy, pointing out the codes and symbols of their "bizarre notions of heritage."[5]

The last component of *The Louisiana Project* is a group of photographs taken at sites in and around New Orleans. These are powerfully composed pictures, many depicting historic buildings in which the Greek Revival and Italianate architecture appears to embody the social aspirations of the local elite's collective imagination. There is the grand plantation house Nottoway, one of the largest antebellum plantation houses in the South.[6] In 1860 John Hampden Randolph, the builder and holder of the property during that time, had 155 black slaves working his sugarcane plantation. There is the antebellum country house, Malus-Beauregard, built in 1833 on the site of General Andrew Jackson's victory over British troops at Chalmette during the War of 1812. Known as the Battle of New Orleans, it was the last battle of the last war ever fought between England and the United States. The victory preserved America's claim to the Louisiana Purchase and prompted a wave of migration and settlement along the Mississippi River. And finally, there is the Whitney House, built in that pivotal year 1865. The house is now

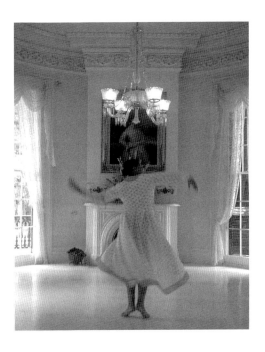

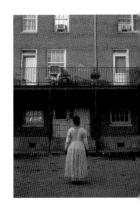

a bed-and-breakfast inn, boasting "Southern hospitality" and "Old World charm."[7]

As a sobering counterpoint to these scenes of faded grandeur, Weems also includes industrial sites along the Mississippi River in the New Orleans region. Weems has said, "I thought it would be important to move along the Mississippi, to move along that river, which has been such a powerful stream in the American industrial landscape and, of course, in the American psyche."[8] She was thinking about what the Mississippi River meant to the various countries—France, Britain, Spain, and, ultimately, the United States—that vied for its control since controlling that river meant controlling the dissemination of wealth throughout the rest of the region. There are railroad tracks, a granary, an aboveground burial site, and a cluster of water towers. Each site is an emblem of Louisiana history and the changing nature of its character. For instance, there

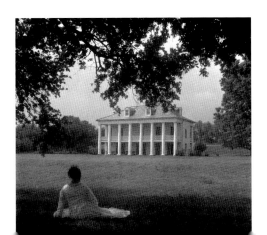

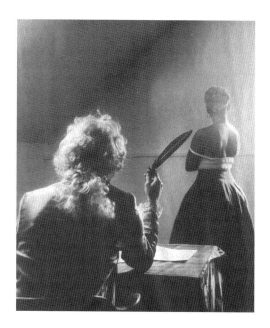

is a picture of Iberville, one of the earliest federal housing developments, built in 1939 on the site of the former red-light district known as Storyville. Iberville was originally built to house white servicemen and their families, but is now occupied by black residents, 84 percent of whom are living in poverty.[9]

In each photograph, Weems herself is pictured, usually with her back to us. She wears a plain, loose-fitting housecoat and appears to look intently at the scenes before her. In some images she moves gracefully through the grand and ornate spaces, dancing or twirling with a freeness of gesture that suggests liberation. In other images, she's a surrogate for the viewer and her gaze provides a point of entry into the larger social space being observed. Because Weems includes herself in the pictures, each image becomes a tableau. No longer are we gazing at a neutrally documented scene; we now view the scene through Weems' eyes and, by extension, her consciousness.

One of the most jarring images is a picture of Weems standing before a Coors Light billboard advertisement that depicts a group of young black men flashing gang signs next to a text that reads "Board of Directors" and a picture of a beer bottle. This found image so perfectly encapsulates the disempowerment of black Americans in the region, that all Weems needed to do to convey her critique was simply point her gaze (and her camera) toward the image. Says Weems, "I long to see images of black people that are more than simply prepackaged stereotypes. It was really rather shocking that in this

town, which is 50 percent black, at least, that there are no images of black people anyplace, with the exception of this billboard that happened to be on the side of a liquor store. That is how much we have been reduced in this country."[10] In all of these photographs, the building façades seem analogous to masks, each one conveying a different character, status, history, and identity. Weems thinks of all these images as a subtle critique of a culture that almost looks as if it's falling down, but is very carefully propped up by a series of actions like the careful maintaining of the old plantations as

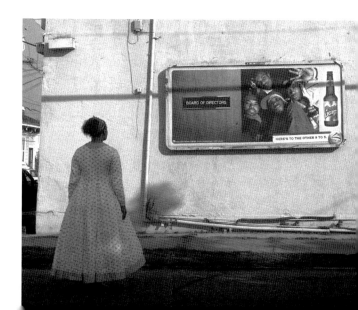

historic sites. The preservation of those buildings is mired in a deep yearning for the past.

Weems' focus on masking and façades underscores the notion that social hierarchies result from differential relations of power, not birthright. Together, these images graphically demonstrate how identity is constructed through social life and social institutions. Weems also treats this idea in *The Jefferson Suite* (1999) (facing page, top), where she references important moments in the history of genetics. The piece was inspired by the 1998 finding that Thomas Jefferson had fathered children with Sally Hemings, a slave at Monticello. Confirmation of this liaison was based on the results of DNA tests that found a genetic link between the Jefferson and Hemings descendants. *The Jefferson Suite* throws a spotlight on the distinction between hereditary notions of race and those that are socially and economically based. *The Louisiana Project* continues this line of inquiry by positing racial identity as something created through the act of masquerade. It is probably no accident that the founding of the most elite Mardi Gras krewes took place at the same time that the biological theory of race became the dominant paradigm in the late nineteenth century. This theory advanced the belief that cultural superiority was a result of superior racial stock and that racial intermixes resulted in the degradation of this stock. The theory was invented in the eighteenth century as part of a

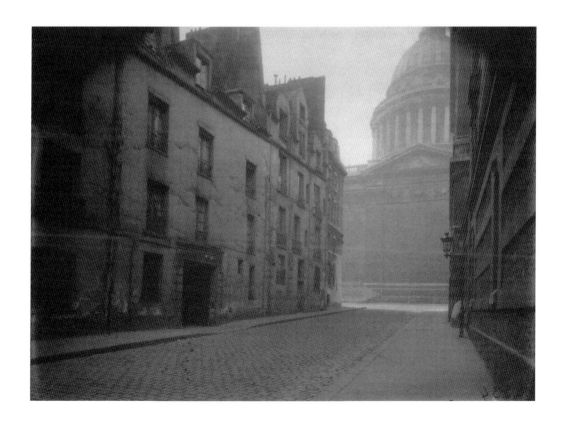

widespread interest in "scientific" explanations of social phenomena, but reached its zenith after the end of slavery to explain racial inferiority as part of a natural order of humankind.

The Louisiana Project documents and questions what is observable on the surface of things. In doing so, the pictures combine two photographic traditions: documentary photography, in which the picture stands as a truthful record of an existing reality, and the tableau vivant, in which the photographer constructs a scene specifically for the purpose of making the photograph. In the documentary tradition, the photograph is considered a "faithful witness,"[11] providing evidence of an authentic, palpable, reality. In the words of photography historian Beaumont Newhall, the documentary photograph makes us feel that "if we had been there, we would have seen it so. We could have touched it, counted the pebbles, noted the wrinkles, no more, no less."[12] This is the documentary tradition exemplified by Charles Marville, who recorded the streets of Paris in the 1860s for the French government before Napoleon III

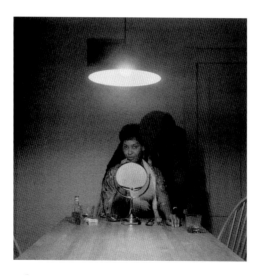

had the great boulevards cut through the city, and Eugène Atget (preceding page), who photographed the same city fifty years later finding human content in street scenes in which no human appears. This is the tradition of Walker Evans, who made pictures of the American social landscape containing "bare-faced facts, facts presented with such fastidious reserve that the quality of the picture seems identical to that of the subject....It was puritanically economical, precisely measured, frontal, unemotional, dryly textured, insistently factual."[13] Yet these pictures are also tableaux vivants, propositions, or investigations into the hidden subtext of these façades. In a tableau vivant, the aim is to convey a symbolic meaning through the choice, costuming, and posing of models. In *The Louisiana Project*, the model is Weems herself. The creation of the tableau and the inclusion of her own image infuses the work with a critical edge.

Weems has often included images of herself in her work, yet never before has the image of the artist come across so strongly as a witness. In *The Kitchen Table Series* (1990) (this page), Weems presents herself as a character sitting at a kitchen table, sometimes alone, sometimes with a man, another woman, or a young girl. The works explore the nature of relationships, and, in them all, Weems is the protagonist. In *Ritual and Revolution* (1998) Weems appears as a goddess-like storyteller set in a timeless temple comprised of banners printed with photographs of ancient ruins, statues, and landscapes. She recites a narrative in a voice that alternates between an all-observing narrator and a participant in the events recounted—the Middle Passage, the Storming of the Bastille, the October Revolution, Nazi Germany. Most recently, in *Dreaming in Cuba* (2003) (facing page), Weems presents a series of black-and-white tableaux in which the

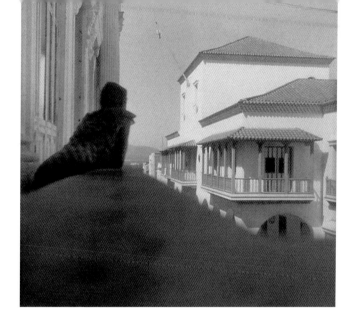

artist places herself in rural and urban settings in an attempt to record the history of Cuba and understand the essence of social revolution.

In *The Louisiana Project*, Weems is verifying experience. "How can I project myself into this scene," she wondered, "not as Carrie Mae Weems…but in a way that I can stand in for something that is much larger than 'I,' even though it, of course, is all fillered through the 'I' voice. 'I,' 'Us,' 'They' become one at these seminal places operating as historical markers that tell us something about who we are."[14] In the new work, Weems is not a woman who looks back at the viewer, as in *The Kitchen Table Series*, engaging in a narrative, dialogue, or exchange. She is not a statuesque goddess, who is both narrator and object of desire as in *Ritual and Revolution*. In *The Louisiana Project*, Weems is a silent, yet powerful, witness. Weems gives herself up to the larger concept of the work and asks, "How clearly does one see oneself and what does it take to see oneself clearly without interference, without fracture, without fragments?"[15] How does one talk about history without becoming locked into old roles and stereotypes? How does one talk about birthright, legacy, and inherited disparities of wealth and social standing in a culture that vehemently denies such ideas exist? According to Weems, "You keep working. You go through a series of moves, not necessarily to reveal the truth, but to get closer to an understanding of the truth."[16] This is *The Louisiana Project*.

Susan Cahan is an art historian and curator who specializes in contemporary art and the history of museums. She is currently the Des Lee Endowed Professor in Contemporary Art at the University of Missouri–St. Louis.

NOTES

1. See James Gill, *The Lords of Misrule: Mardi Gras and the Politics of Race in New Orleans* (Jackson, MS: University of Mississippi Press, 1997), 28–30.
2. Gill, 4.
3. Rosalind Krauss, "The Grid" in *The Originality of the Avant-Garde and Other Modernist Myths* (Cambridge, MA, and London: MIT Press, 1987), 20.
4. Carrie Mae Weems, interview by author, tape recording, January 11, 2004.
5. Carrie Mae Weems' spoken text from *The Louisiana Project* is printed on pages 26–27 of this book.
6. This 53,000-square-foot plantation home was constructed by John Hampden Randolph in 1858.
7. http://www.hh.whitney.com
8. Weems, interview.
9. U.S. Census Bureau. *Census 2000 Sample Characteristics (SF3).* From a compilation by the GNO Community Data Center. http://www.gnocdc.org
10. Weems, interview.
11. Beaumont Newhall, *The History of Photography* (New York: The Museum of Modern Art, 1978), 67.
12. Newhall, 71.
13. John Szarkowski, *Looking at Photographs: 100 Pictures from the Collection of The Museum of Modern Art* (New York: The Museum of Modern Art, 1973), 116.
14. Weems, interview.
15. Ibid.
16. Ibid.

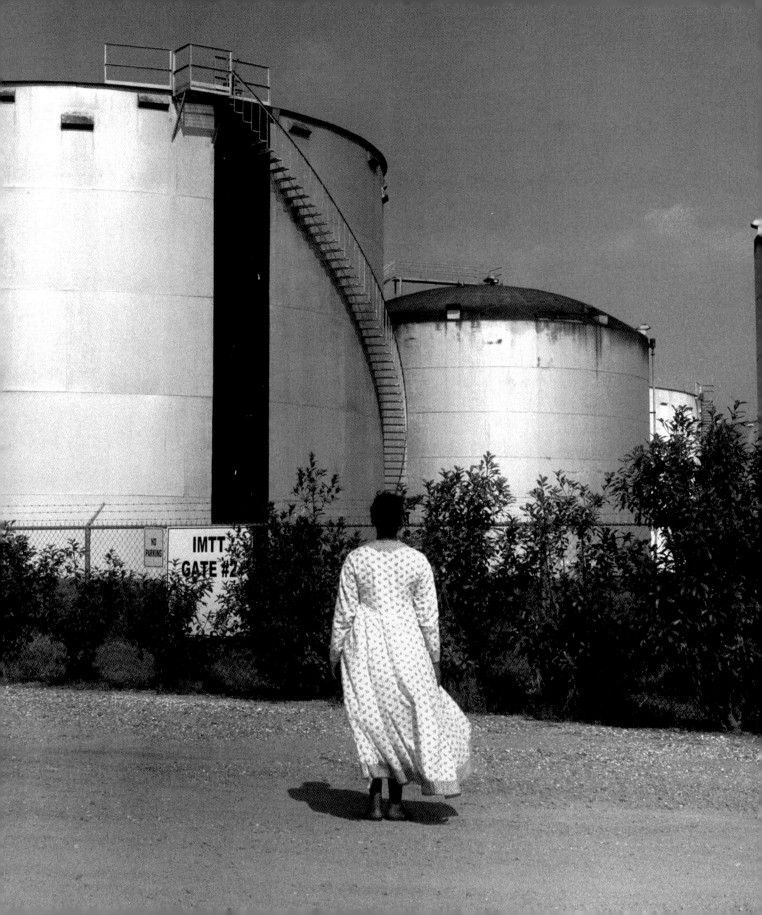

LOUISIANA LEGALITIES **IN BLACK AND WHITE**

By Pamela R. Metzger

N HER BEAUTIFUL and unsettling *Louisiana Project*, Carrie Mae Weems bears witness to Louisiana's tangled and troubled mythology of race and gender. Weems is literally a witness; her photographs are self-portraits, in which she is a time-traveler, visiting and reflecting upon Louisiana's racial and economic history pre- and post-Civil War. Weems is also a figurative witness, one whose images document, in part, Louisiana's struggle over the meaning of race.

In this essay, I hope to underscore the way in which, for me,[1] Weems' photographs and videography illuminate one aspect of Louisiana's preoccupation with racial identity—the legal system's shifting modes of identifying race. Two important caveats accompany this essay. First, Louisiana has a rich French and Spanish heritage that contributes much to any discussion of Louisiana's racial codes.[2] However, limits of time and space have forced me to confine this essay to the periods of time that Weems focuses on: the antebellum period and the modern era. Thus I examine legislation and litigation, during the years between 1845 and 1983, to show how ideologies about race were voiced in the Louisiana legal system during those eras.

Second, in examining the issues that arise in legislation and litigation, whether from a race

essentialism or race performativity[3] perspective, it is crucial to note that the very question excludes from consideration the largest mass of people—those whose "race" a viewer believes she can identify from skin tone. The cases addressed by this essay are cases at the margin, cases in which determinations of racial identity are not readily available to the viewer. These are cases in which a mask has fallen over the visual object and the viewer experiences doubt or confusion about the object's racial identity.[4] As in many other areas, society grants law the power to unmask the "truth," in these cases, to unmask the "true" racial identity of those whose physical appearance defeats the rigid and autonomic demarcations of race. In Louisiana, courts have struggled to decide what lies beneath the mask: The law long dictated that blood determined race; but, societal pressures forced the court system to deal with performative, rather than ancestral, notions of race identity.

IN 1845, SALLY MILLER sued Louis Bellmonti for her freedom, claiming that she was a white woman and could not, therefore, be legally enslaved.[5] Miller claimed German ancestry and alleged she had been separated from her family after they arrived in the New World. Miller claimed that she became a bonded servant to John F. Miller,

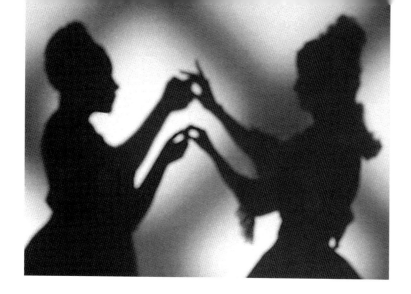

who sold her to Bellmonti at a public auction.

In the litigation, both sides argued about whether Sally Miller *acted* like a white woman. Miller's lawyer used her character as evidence of her whiteness. He argued, "The perseverance, the uniform good conduct, the quiet and constant industry, which are found in those [white persons] she claims as relatives, have always been found in her . . . and these traits prove her *white nature*."[6] Public opinion that Miller was white, that is, her ability to command a successful performance of whiteness, merely showed "her moral power, and weight, and influence," an influence, her attorney argued, which "no one but a white woman could possibly raise up and control—an influence as inconsistent with the nature of an African, as it would be with the nature of a Yahoo."[7] The moral or performance aspect of whiteness was seen as so critical to racial identity, that her lawyer argued that moral characteristics would reveal race long after "distinctions and differences of physical conformation" had disappeared.[8] For example, he argued, "The Quartronne is idle, reckless, and extravagant; this woman is industrious, careful, and prudent. The Quartronne is fond of dress, of finery and display; this woman is neat in her person, simple in her array, and with no ornament upon her, not even a ring on her fingers."[9]

Similarly, when Alexina Morrison sued the aptly named James White for her freedom, the courtroom battle lines were drawn around the calculus to be used in racial identification: Appearance and performance battled against "science" and geneaology.[10]

Morrison's lawyer tried to convince the jurors that Morrison performed as a white person and therefore was a white person. She looked white, she acted white, therefore she was white, or so the argument went. In contrast, White tried to convince the jury that racial determination was a science, one that required considerable expertise. To the extent that White tried to argue that performativity was relevant, he argued that Morrison had had an extramarital affair. White's lawyers thereby implied that Morrison's sexuality proved her biological non-whiteness.[11] The Louisiana Supreme Court found in White's favor, declaring performativity defeated by science. "Fair complexion, blue eyes, and flaxen hair . . . must yield to proof of a servile origin."[12]

In both Miller's case and Morrison's case, legal rules made ancestry the determinative factor in race classification. Yet, in both cases, lawyers and witnesses for both sides reached well beyond records of ancestral status to tell the jury about performance.

"A vision of white womanhood as beauty, purity, and physical and moral goodness" was perceived to be as persuasive as any genealogical or pseudo-biological evidence. Thus for antebellum women seeking legal declaration of whiteness, their task was not to prove blood ancestry, but to "dazzle their neighbors and jurors with feminine evidence of whiteness: beauty and goodness."[13] By "invoking the trope of white womanhood—indeed, by performing it in court," they won freedom by convincing a jury of their whiteness.[14]

As Professor Gross notes, these types of arguments were about "the qualities of character that defined whiteness," in a world in which "virtue and honor, good conduct, industry, and so forth" marked white performativity.[15] Thus their lawyers argued that Miller and Morrison revealed their whiteness by their conduct as well as by their light skin.[16]

Performance, however, suffered as a racial yardstick in the years following Reconstruction.[17] Perhaps the end of slavery necessitated a commitment to a pseudo-scientific calculus of racial mixing.[18] Certainly the orthodox notion that slavery marked the line between white and black did not function as a guarantor of social/racial status.

Whatever the reason, a desire to identify and preserve (pure) white identity and caste gradations of mixed-race identity pervaded Louisiana's law. Louisiana maintained its Spanish legacy of mixed-caste characterization and, if anything, became more attached to the notion of specific, identifiable, "caste" identity as a way of maintaining a race-based political, social, and economic power structure. In 1910, the Louisiana Supreme Court confidently expressed its view that skin tone accurately expressed specific variations of "race" identity:

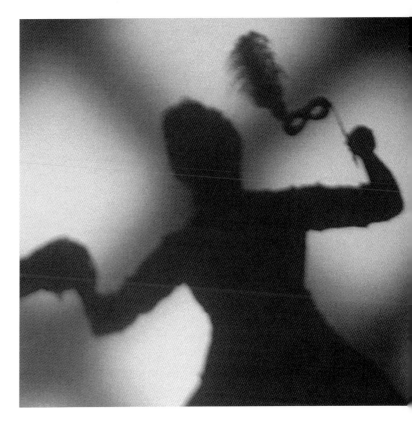

We do not think there could be any serious denial of the fact that in Louisiana the words "mulatto," "quadroon," and "octoroon" are of as definite meaning as the word "man" or "child," and that, among educated people at least, they are as well and widely known. There is also the less widely known word "griff," which, in this state, has a definite meaning, indicating the issue of a negro and a mulatto. The person too black to be a mulatto and too pale in color to be a negro is a griff. The person too dark to be a white, and too bright to be a griff, is a mulatto. The quadroon is distinctly whiter than the mulatto. Between these different shades, we do not believe there is much, if any, difficulty in distinguishing.[19]

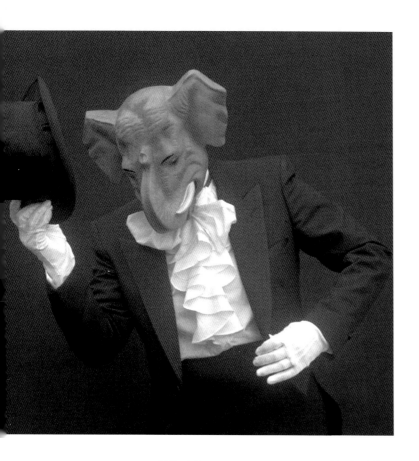

classification reflects a societal judgment: Racial transgression, being "demoted" from whiteness to non-whiteness, or being "promoted" from colored to white, was of greater societal impact than criminal transgression, being demoted from a law-abiding citizen to a felon.

Until 1970, a Louisiana statute embraced the one-drop rule, defining a Negro as anyone with a "trace of black ancestry."[20] And, as late as 1983, Louisiana law provided that: "In signifying race, a person having one-thirty-second or less of Negro blood shall not be deemed, described or designated by any public official in the State of Louisiana as 'colored,' a 'mulatto,' a 'black,' a 'negro,' a 'griffe,' an 'Afro-American,' a 'quadroon,' a 'mestizo,' a 'colored person' or a 'person of color.'"[21]

The law also mandated that a person's race appear on his or her birth certificate, where race would be classified according to the one-thirty-second rule: One-thirty-second African blood meant that a person would be designated as black. The official registry of race was not to be disturbed except, as noted above, upon the "no doubt" standard of proof. This law stood until one woman's lawsuit forced a political change. Yet her lawsuit was emphatically not in the tradition of civil rights lawsuits. Instead, Susan Guillory Phipps sued for a legal declaration of whiteness.[22]

Born in 1934, Susan Guillory Phipps grew up on a French-speaking farm in Louisiana's Cajun country. When she was forty-three years old, Phipps needed a passport. In order to obtain the passport, Phipps needed a copy of her birth certificate. When she obtained that birth certificate, Phipps was stunned to see that the birth certificate said she was "colored." The "revelation" reportedly made Phipps sick for three days. Phipps later told reporters, "I was

IN 1930s LOUISIANA, the Louisiana Supreme Court held that there was a presumption of whiteness extended to those whose birth certificates claimed whiteness. That presumption was to be maintained unless or until the opposing party proved, without doubt, that the person was not white. Of course, the law required only proof beyond a reasonable doubt to declare an individual to be a criminal. Thus we may safely infer that the relative strength of the presumption attached to racial

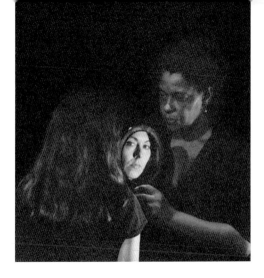

brought up white, I married white twice." And, in an article in *The New Yorker*, Calvin Trillin reported that Mr. Phipps enthusiastically concurred that his wife was white: "Hell, she ain't a nigger."

Phipps sued the Department of Vital Statistics in an effort to force a change to her birth certificate. Phipps did not seek a change to her birth certificate in order to obtain concrete political or social privilege. By 1983, whether white or black, Phipps was entitled to vote, to stay in any hotel, to ride in any seat on a bus, and to be served in any restaurant. Rather, "this case was about Phipps' right to claim a nineteenth-century version of racial whiteness and be believed."[23] Phipps wanted legal confirmation of a racial identity that had performative moral connotations. Yet, by law, Phipps was black.[24]

Phipps sued the state of Louisiana to change her racial designation. The precise form of the petition was a request to change the race classification on her parents' birth certificates to "white" so that she could, in turn, be designated white. She lost.

In 1985, the local court of appeals affirmed the district court's decision, holding that Phipps' perception of herself as white was "irrelevant" to her legal designation. That she had lived as a white woman, and that her community treated her as white, was similarly irrelevant: "That appellants might today describe themselves as white does not prove error in a document which designates their parents as colored."[25] The court vacillated wildly between scientific and social constructivist theories about race. Although the court acknowledged expert testimony showing that race cannot be determined with scientific accuracy, the court insisted that legal racial determinations were not based on science. While acknowledging that "individual race designations are purely social and cultural perceptions," the court insisted that because "those subjective perspectives were correctly recorded at the time the appellants' birth certificates were recorded," Phipps self-perception was irrelevant. Race was legally immutable.

Thus, in the cultural mélange of antebellum Louisiana, performance of the tropes of whiteness was the determinative factor in legal decisions relating to racial identity. In contrast, in the modern era, the law purported to look to science, blood, and bloodlines, to fix permanent racial identity.[26]

AS PROFESSOR ARIELA GROSS points out, trials bring "to the surface conflicting understandings of identity latent in the culture."[27] In a trial about racial identity, "people who [have

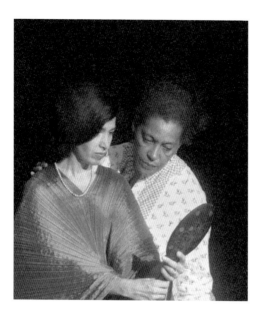

about racial identity. Weems offers powerful images of the artist herself forcing individuals to look themselves in the mirror. She forces the viewer to compare the visual image seen with the subject's (presumed) self-image. Thus she suggests that the mirror may reveal something different than the mask imposed (or superimposed) by the viewer.

Weems' work also illuminates political and legal themes that accompany questions about racial identities in Louisiana. True, the issues arise at the margin, but they do so precisely because passing, or the option of litigating race, was open only to those whose physical appearance made ambiguity possible. During the antebellum period in Louisiana, ambiguous cases were defined by law, based largely upon "performativity." Thus, "doing the things a white man or woman did became the law's working definition of what it meant to be white. . . . Performance operated in a law-like fashion, prescribing certain rules of behavior for people of different races."[29]

Weems' sense of the importance of performance and racial identity emerges in her silhouetted video stills. One in particular illustrates how we, as viewers, still incorporate performance as a critical, perhaps predominant marker of race. In this image (facing page), Weems provides viewers with performance-coded messages about the racial identity of her subjects. Three women are depicted in shadow only: Two women sit, one woman stands. There are no colors, no fabrics, no expressions, and no skin tones that would give the viewer explicit information about the women's racial identities. Yet, the women's performances help the viewer "read" their race. The two seated women are white; the server is of color. Those who are waited upon are white. Those who serve are of color.

lived] on the 'middle ground' of ambiguous status [must] . . . fall on one side of the line."[28] The Phipps' case does not reflect a jury verdict and therefore does not carry the communal endorsement that accompanied Miller's case. Nevertheless, the swell of publicity about the Phipps' case (it was reported widely in the national and international press) was an extraordinary demonstration of public preoccupation with racial identity.

The Phipps' case demonstrates the way in which self-identification in the racial landscape matters not to the law. In the modern era, the law seeks to tell us that the mirror reveals less and less

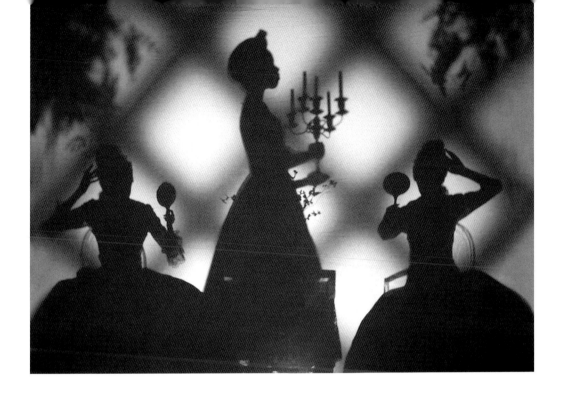

The two sitting women are engaged in self-reflection. They examine their faces in the mirror, touch their hands to their hair. Their gaze is wholly self-involved. Neither acknowledges the presence of the other and neither acknowledges the presence of the third figure. The third figure is, the viewer presumes, a slave or a servant. She is erect, unadorned, and disengaged from the other women's narcissistic self-reflection. Instead, she works—carrying a candelabrum. In a sense, her social classification—worker/slave—illuminates the social classification of the other women. In this way, Weems challenges the "unmarked quality" of whiteness, a quality that is belied by the legal controversies over racial identity.

Of course, in the law, as in *The Louisiana Project*, we are confronted with the effort to mark race, and to decide who is empowered to define its boundaries? Is it the individual, her society, or the law? Whereas Miller and Morrison sought legal relief to elevate their statuses from black slavery to free (and legal) whiteness, Phipps sought legal relief to salvage her reputation from the stain imputed to her by the State's declaration that she had a colored identity.

Weems' *Louisiana Project* illuminates the performance aspects of racial identity and challenges the purportedly "unmarked quality of whiteness."[30] After all, in recognizing that performance marks racial identity, one necessarily accepts the possibility racial identity can be marked by dress, behavior, occupation, or performance, as well as by appearance, blood, and ancestry. And, as Weems knows, that performance both contradicts the ideology of race and poses a challenge for the future: Can we re-imagine our dialogue about race, performance, and equality?

Pamela R. Metzger is associate professor of law at the Tulane Law School and is the director of Tulane's Criminal Law Clinic.

NOTES

1. I draw heavily on the legal scholarship of others who have given long and serious consideration to the themes raised in this essay and in Weems' *Louisiana Project*. I am particularly indebted to the scholarly work of my colleague, Robert Westley, as well as the work of Ariela J. Gross. My contribution to this essay lies in my attempt to synthesize and summarize the intersection of Weems' vision and the scholars' revelations.

2. As Robert Westley has noted, "Louisiana Creole society probably contributed more to the range of racial descriptions than any other by distinguishing a person one-sixty-fourth Black as a 'sang-mele,' a person one-sixteenth black as a 'meamelouc,' a person three-quarters Black as a 'sambo,' and a person seven-eighths Black as a 'mango.'" Robert Westley, *First-Time Encounters: "Passing" Revisited and Demystification as Critical Practice.* 18 *Yale Law and Policy Review* 297 fn. 80 (2000).

3. I use the term "performativity" as that term is used by Ariela J. Gross in her work, *Litigating Whiteness: Trials of Racial Determination in the Nineteenth-Century South*, 108 *Yale Law Review* 109, 112 n. 6 (1998).

4. The discourse also presumes that, while the subject may have a personal notion of his or her racial identity(ies), those subjective views are not legally relevant.

5. *Miller v. Bellmonti*. 11 Rob. (LA) 339, La., Jul 1845. Miller's case was well-publicized and came to epitomize antebellum abolitionist horror stories about "tragic octoroons" and "white slavery." Gross, *Litigating Whiteness* at 170. I summarize the details of Miller's case based upon Gross's excellent research on the trial proceedings.

6. Gross, *Litigating Whiteness* at 167, quoting (emphasis added).

7. Gross, *Litigating Whiteness* at 168.

8. Ibid.

9. Ibid.

10. Again, this account is taken from Gross, *Litigating Whiteness*.

11. Gross, *Litigating Whiteness* at 171.

12. Gross, *Litigating Whiteness*, fn. 294.

13. Gross, *Litigating Whiteness* at 166.

14. Ibid.

15. Gross, *Litigating Whiteness* at 167.

16. Gross, *Litigating Whiteness* at 167, quoting.

17. Gross, *Litigating Whiteness*.

18. As Robert Westley notes, those who could "pass" themselves as "pure" white, despite mixed origins, "mark the boundary of us and them." Identifying those boundaries became increasingly important as slavery ended and race became a critical marker of social boundaries. Westley, *First-Time Encounters* at 301.

19. *State v. Treadway et al.*, 139 *Am.St.Rep.* 514, 20 *Am.Ann.Cas.* 1297 (1910).

20. Marvin Harris calls these pseudo-mathematical calculations the principle of *hypo-descent*: anyone who is known to have had a black ancestor should be classified as black. Michael Omi, *Racial Identity and the State: The Dilemmas of Classification*, 15 *Law and Inequality: A Journal of Theory & Practice* 7, p. 8. Winter 1997 (Symposium Issue: Our Private Obsession, Our Public Sin).

21. *La. Rev. Stat. Ann.* § 42:267, repealed by 1983 Acts No. 441, § 1.

22. My account of Phipps' story comes from three sources: Calvin Trillin's article, "American Chronicles: Black or White," *The New Yorker*, April 14, 1986; Westley, *First-Time Encounters*; and Omi, *Racial Identity and the State*.

23. Westley, *First-Time Encounters*.

24. Of course, there was no evidence adduced by the State as to whether Phipps' "black" ancestor was herself of "pure" African origin or was of mixed racial identity. Instead the State presumed that the ancestor was of pure African ancestry. Had Phipps' ancestor been presumed to be of mixed racial heritage, Phipps would have been less than one-thirty-second black and legally white under Louisiana's race laws.

25. *Doe v. State of Louisiana*, 479 So. 2d 371 (1985).

26. In June of 1983, in political response to the Phipps' case, the Louisiana legislature abolished the one-thirty-second rule and conferred upon parents the right to designate the race of newborns.

27. Gross, *Litigating Whiteness* at 118.

28. Ibid.

29. Gross, *Litigating Whiteness* at 112–13, footnotes omitted.

30. Gross, *Litigating Whiteness* at 112 n. 7.

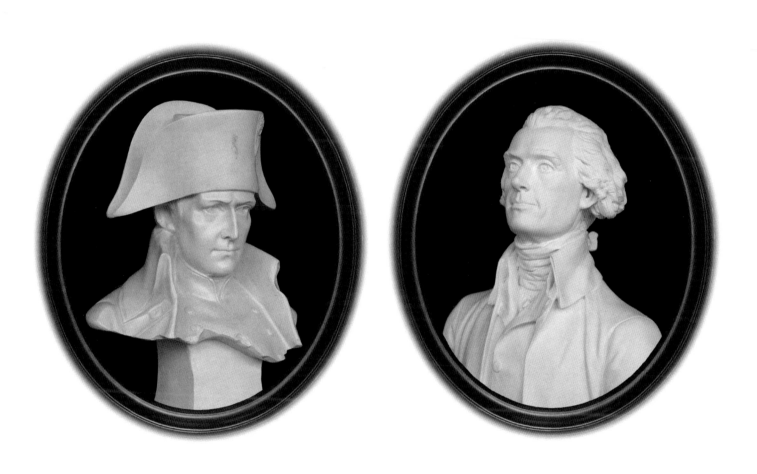

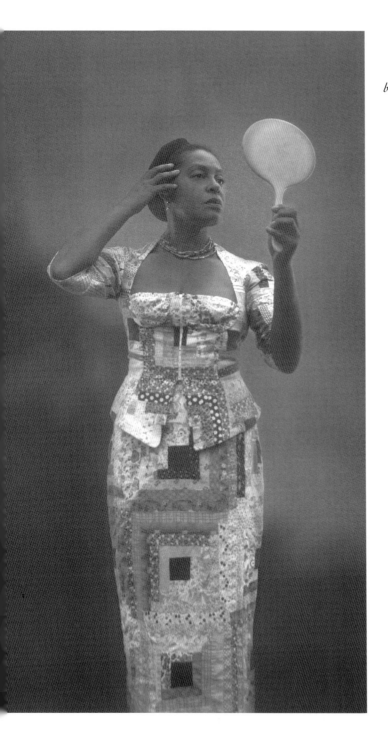

While I knew nothing, not the contours of your mind
or the vast scope of your machinations
or the ordering of your society
but I saw its codes; its designs & its symbols reflected everywhere.

I saw it in the negotiations of the real world
conducted in a land of make believe.
Yearly enactments confirming and conferring
your upper hand, your will to power, your need to control.

I saw it in the Lords of Misrule: masked men and despots
adventurers, capitalists, and mad men:
white knights and camellias in shining armor
attempting to save the day.

I saw it in secrets of secret societies:
Comus, Momus, and Rex, too.

I saw it in the Krewes,
each holding fast to bizarre notions of heritage,
systems of traditions and European aristocracy,
reveling in transgression,
pomp and circumstance,
laughing at you, laughing at me.

I saw it in the gentleman clubs
organizing and conducting the business of the day.
Passing on the key to the kingdom in accord
with birth right, privilege, and carnival.

I saw it in the magnificently mounted masquerades of metaphor
made possible by the Veiled Men of the Mystic Knights
shrewdly staging staggering Balls of grand illusions,
elaborate concoctions meant to assist in the subterfuge,
an extraordinary and frightening performance,
one designed to misdirect and to misguide
yet always present.

I saw it in the thin blue veins of the blue bloods
forever limiting the game of chance,
guaranteeing the guarantor the winner,
ensuring a careful transfer of power
to you and you alone.

Frozen in the autumn of the patriarch
I saw it in the presenting of your daughters,
moments made grand by cotton and courtly cotillions.
Smartly selling them for pennies on the pound
to the highest bidder as though the cash reward hid the crime.

I saw it in the acquiescence of your wives and concubines
who seeking comfort in the confines of wealth,
preserved their Interests by following you
down dissipating avenues
of thought and action, word and deed
and unaware of the consequences
of your miscalculations

I saw it in your rocking
on your now faded veranda,
your wife at your side,
your children at your feet,
your mulattoes and placage,
your ladies in waiting,
patiently waiting to leave your table.

I saw it in the flickering luminosity
falling upon the myths of your
glorious past.

I saw it in your
plea not to be seen,
in the harsh light of time and history,
in your moment of decline,
disheveled, in distress and in disarray.

And finally, I saw it in your
endless crowning of your future.
Delaying your date with fate,
the end of your reign,
your last dance,
perhaps,
a final disruption of the constant refrain of
If ever I cease to love.

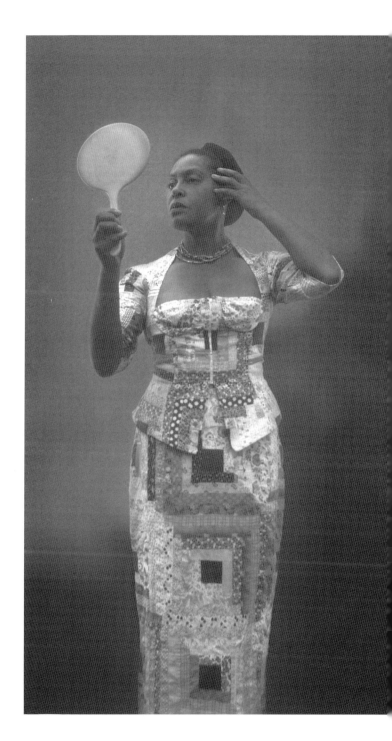

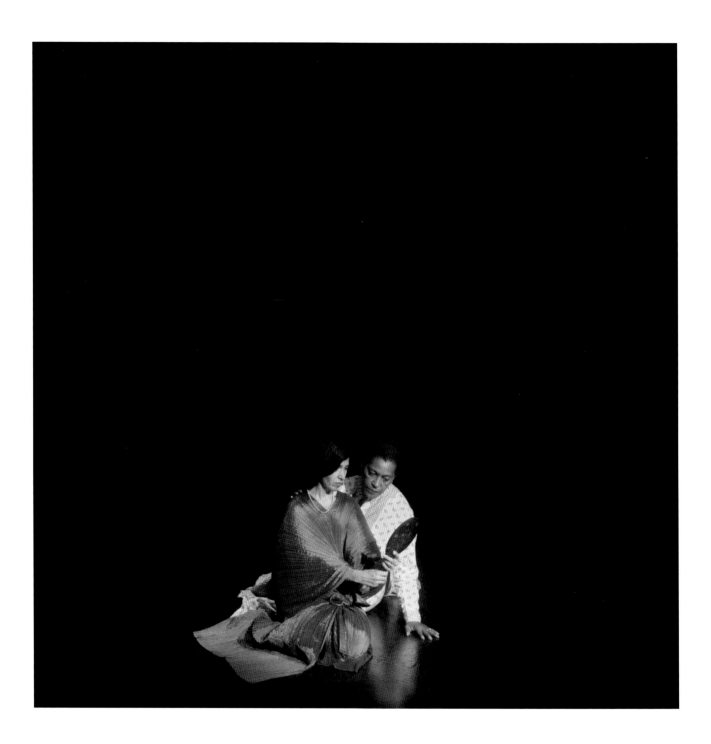

28

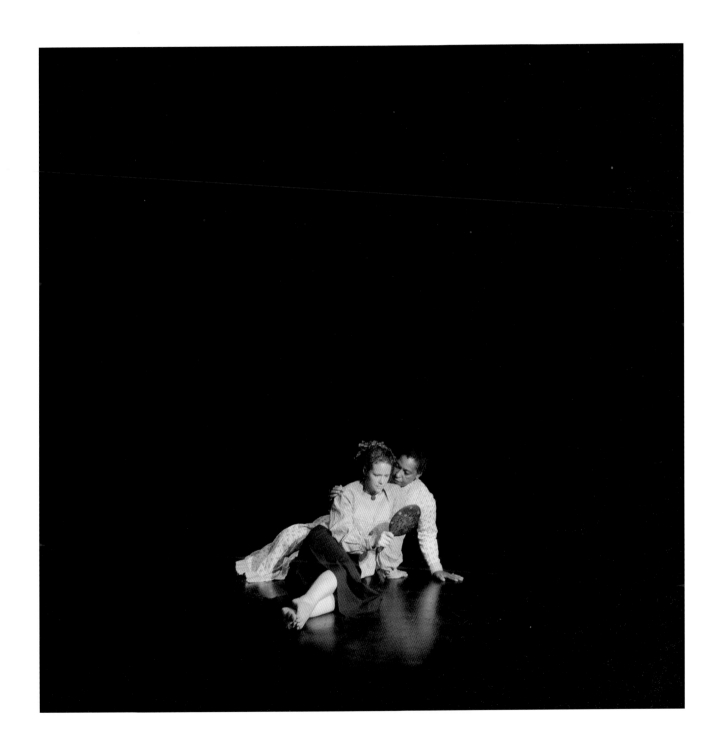

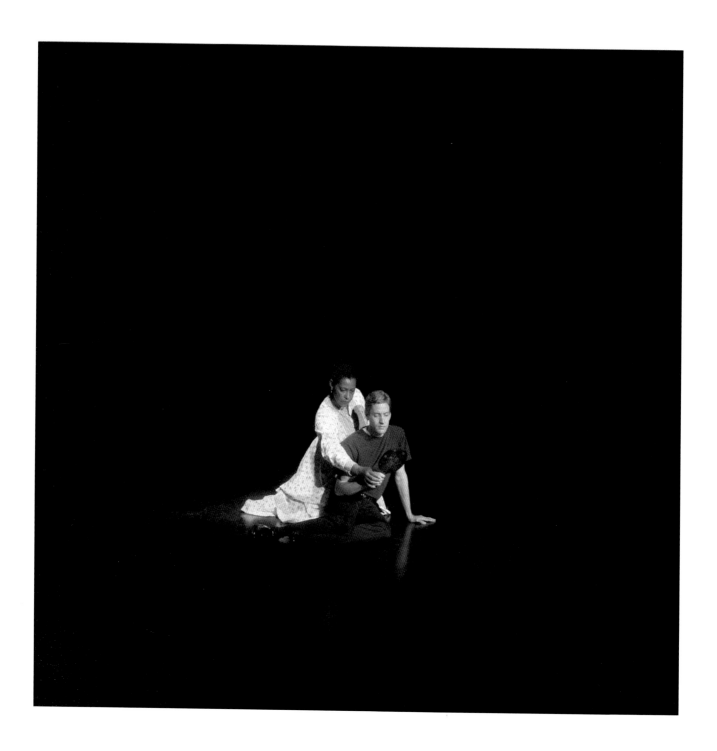

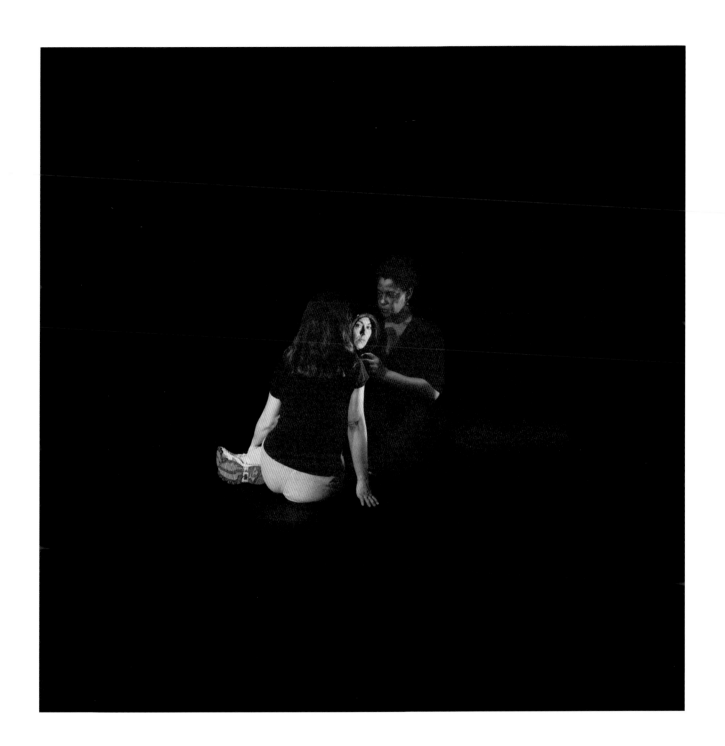

New Orleans is the spring from which so many thousands have drawn their wealth, but it is also a bitter cup of suffering, misery, and despair. New Orleans is now the prima donna of the South, the whore insatiable in her embraces.

BARON LUDWIG VON REIZENSTEIN
The Mysteries of New Orleans

THE WITNESS

I was not amongst that gentle crowd of ragged negroes gathered together in the evening to stand under the old oak tree and sing sad spirituals, while the gentleman of the house and his guests reflected with glee, the naturalness of their privilege. No, I was the chambermaid, the whore, and the witness.

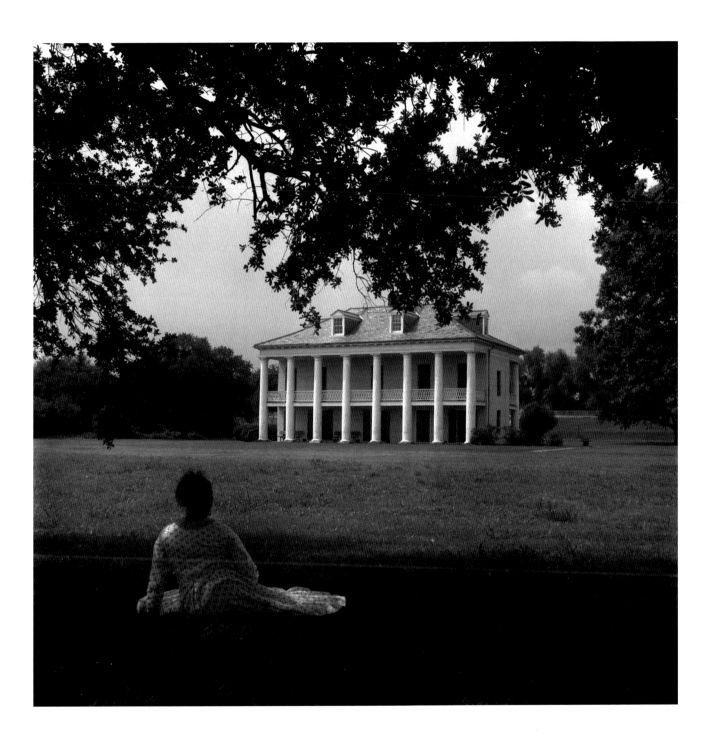

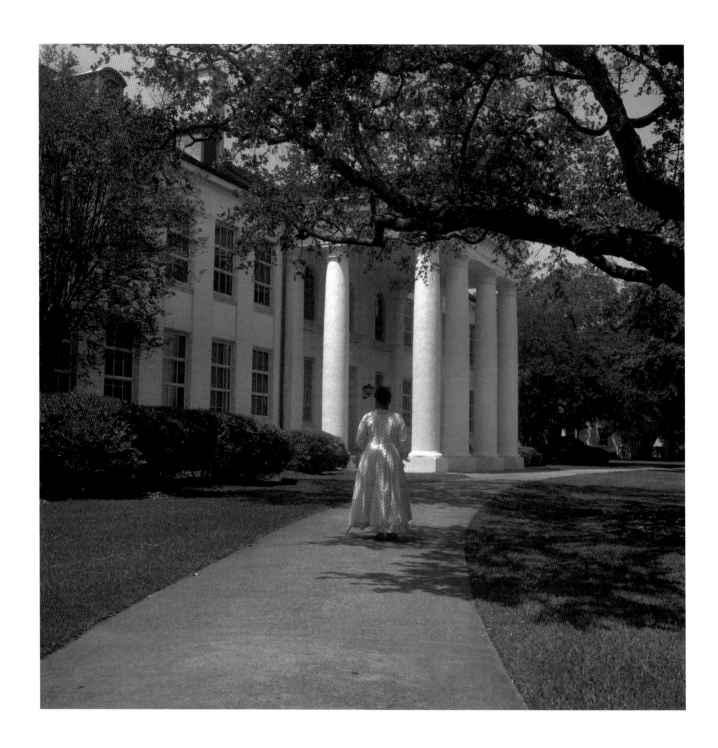

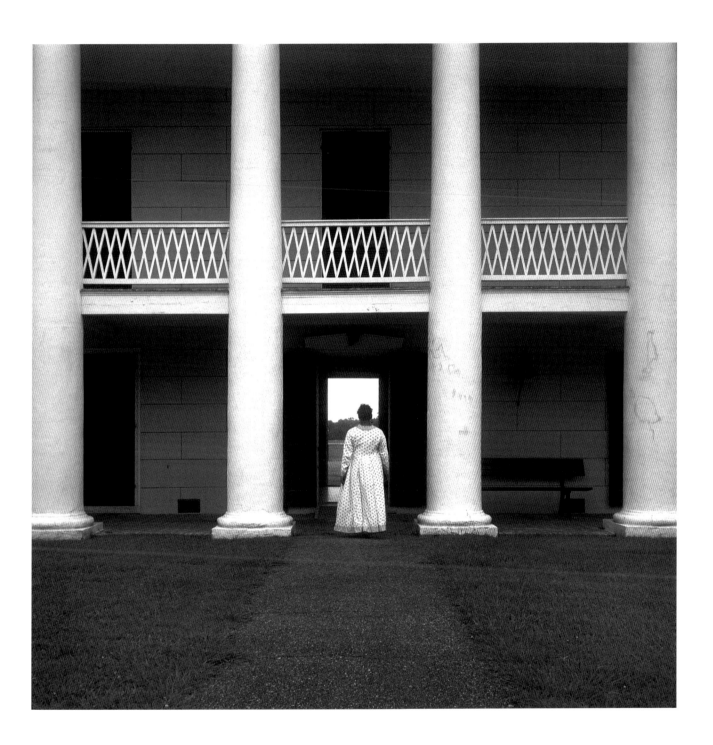

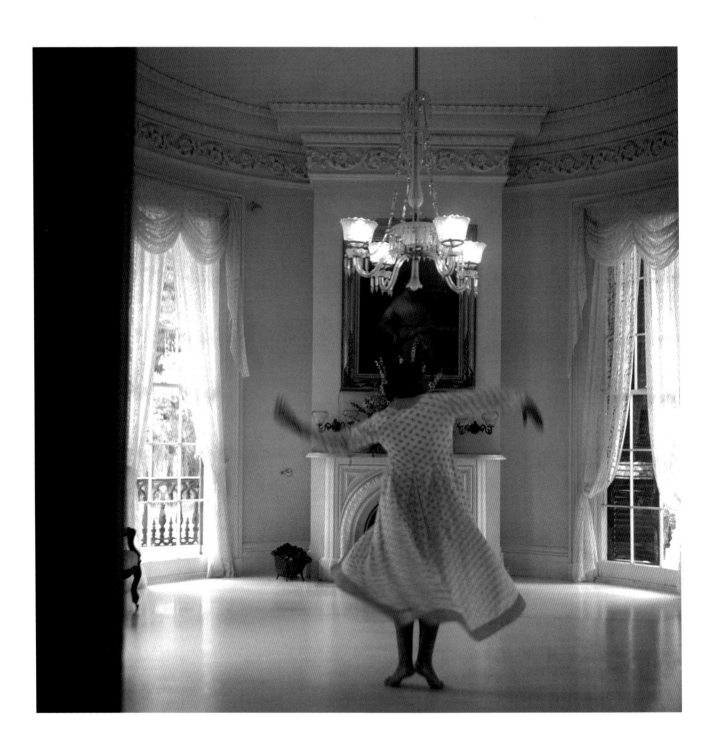

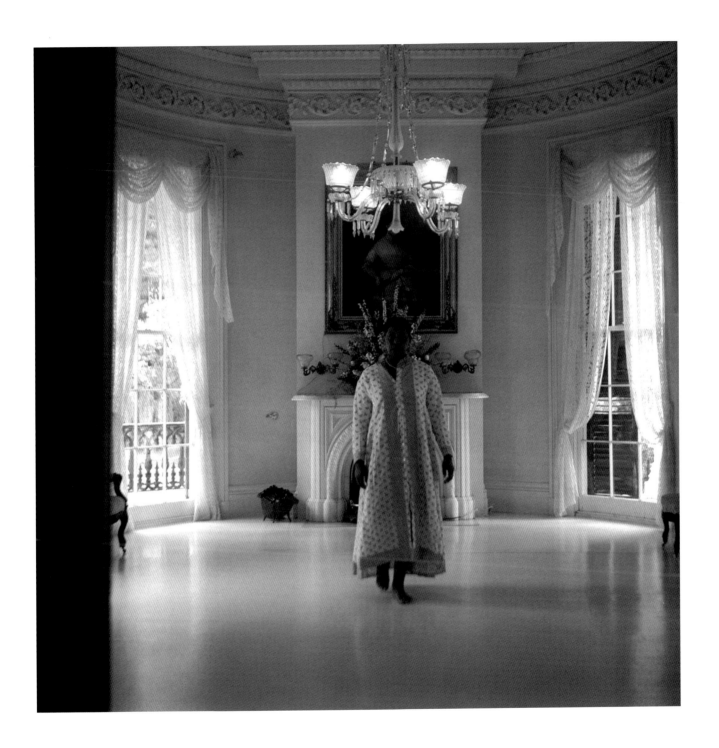

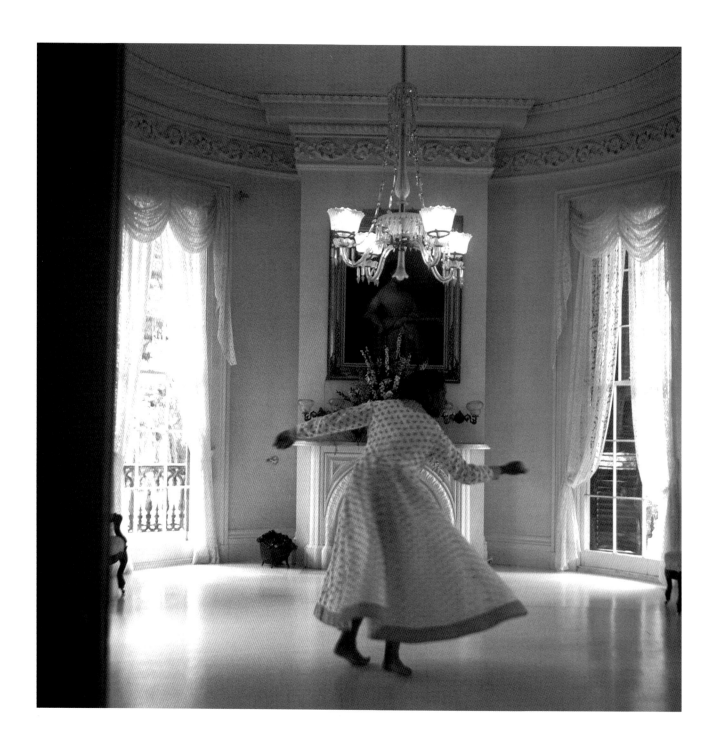

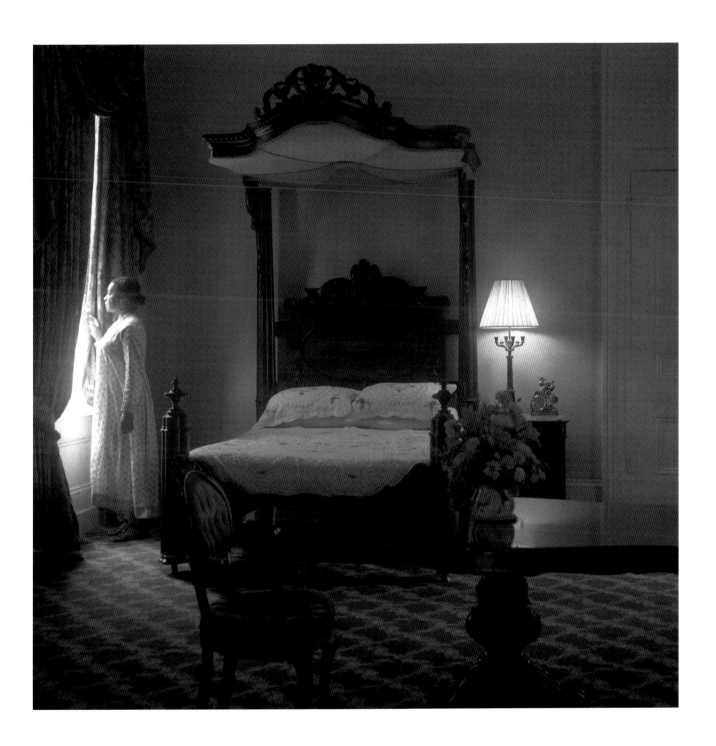

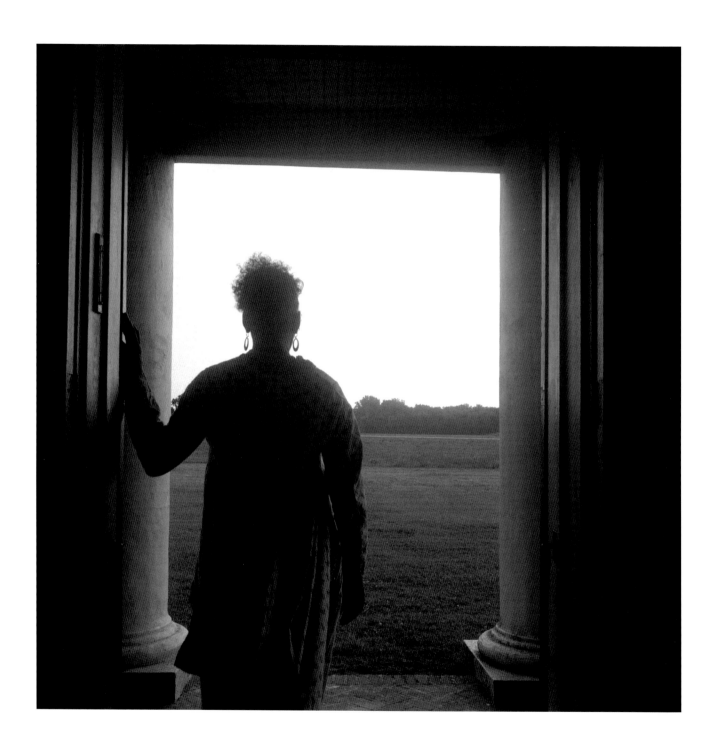

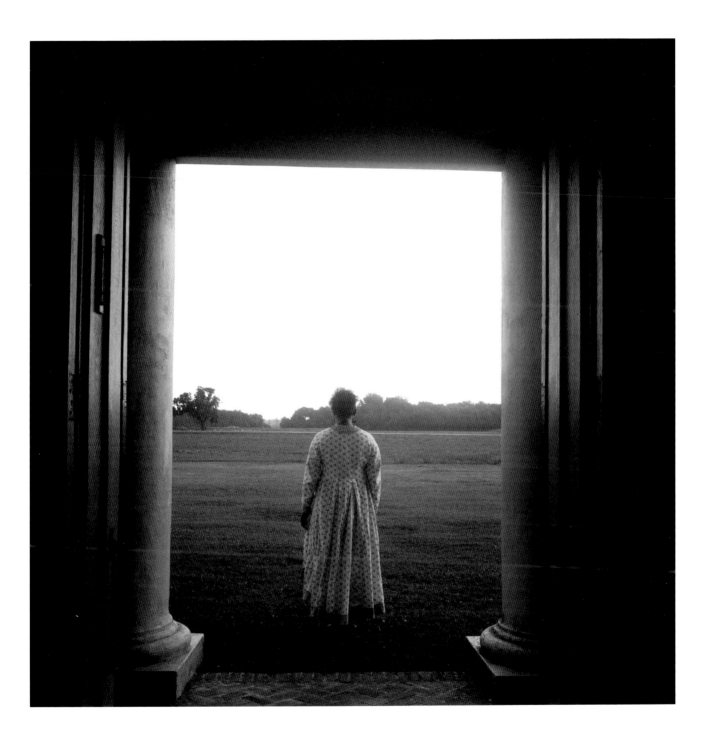

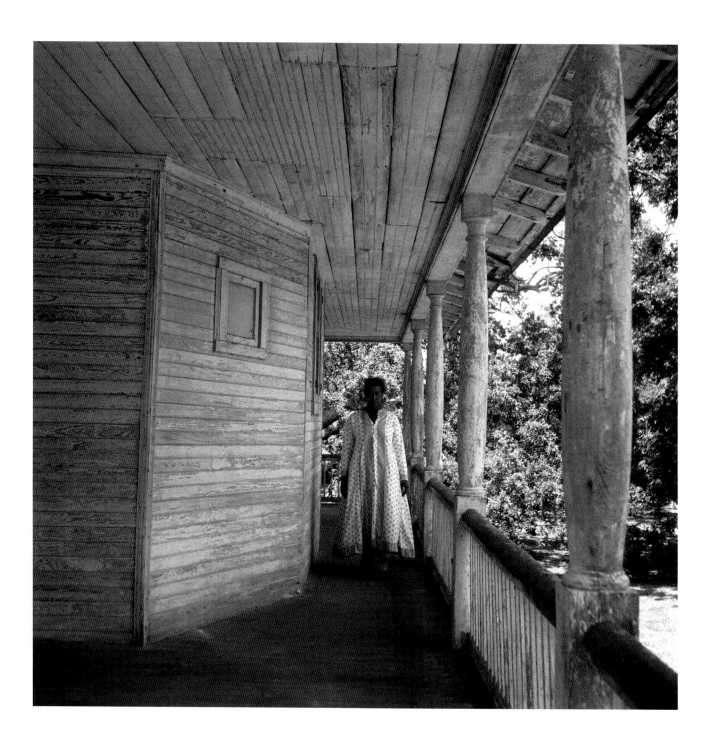

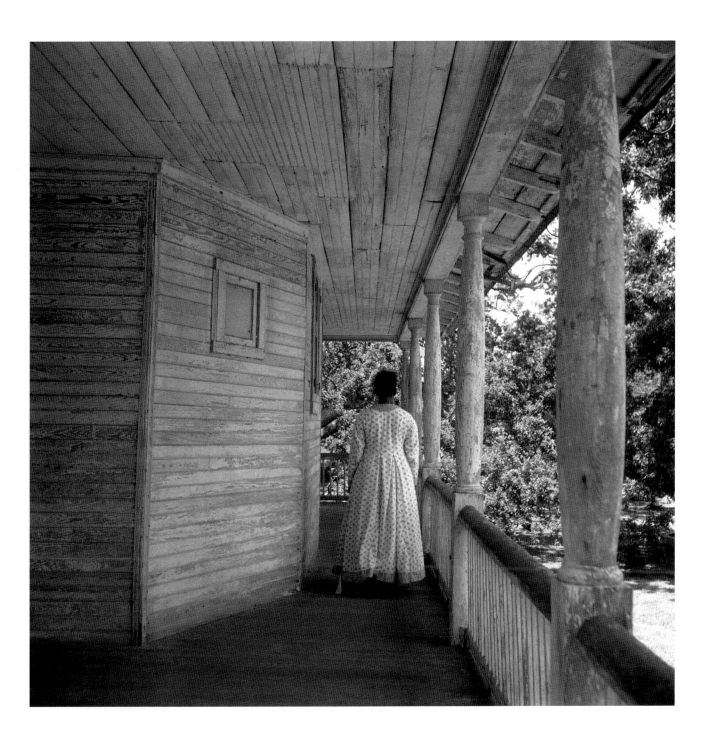

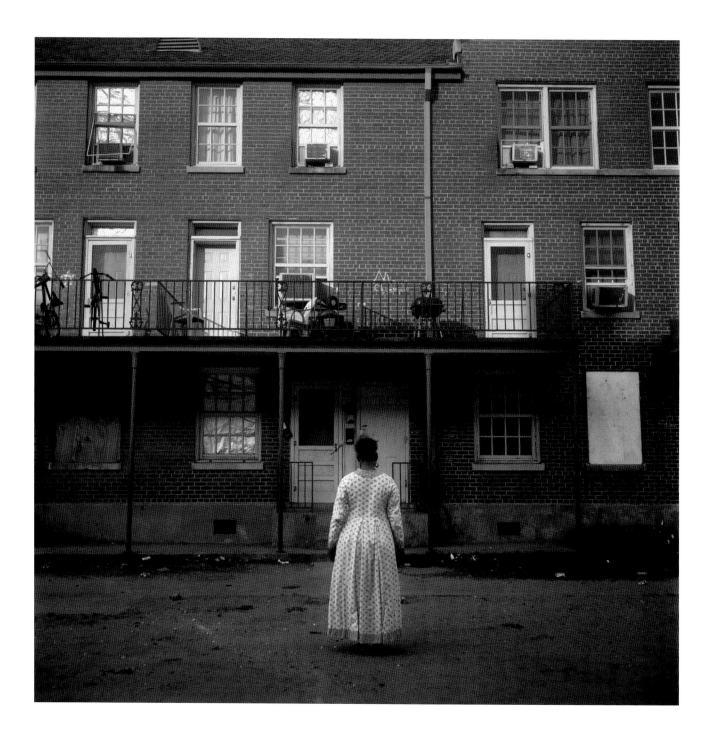

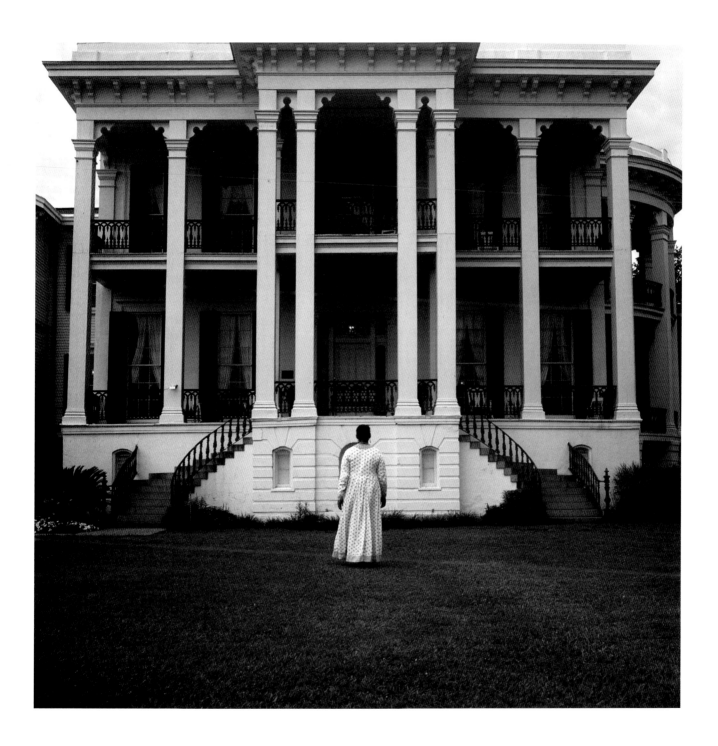

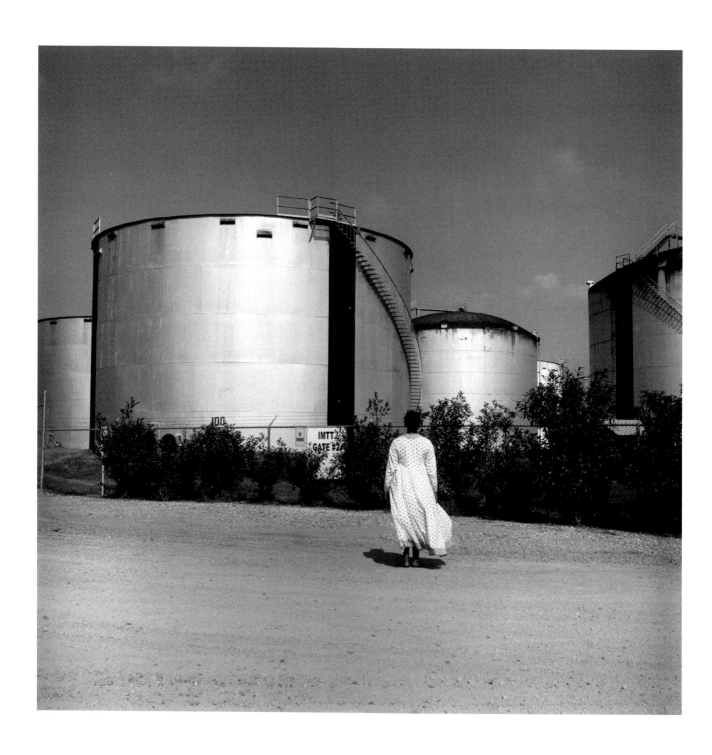

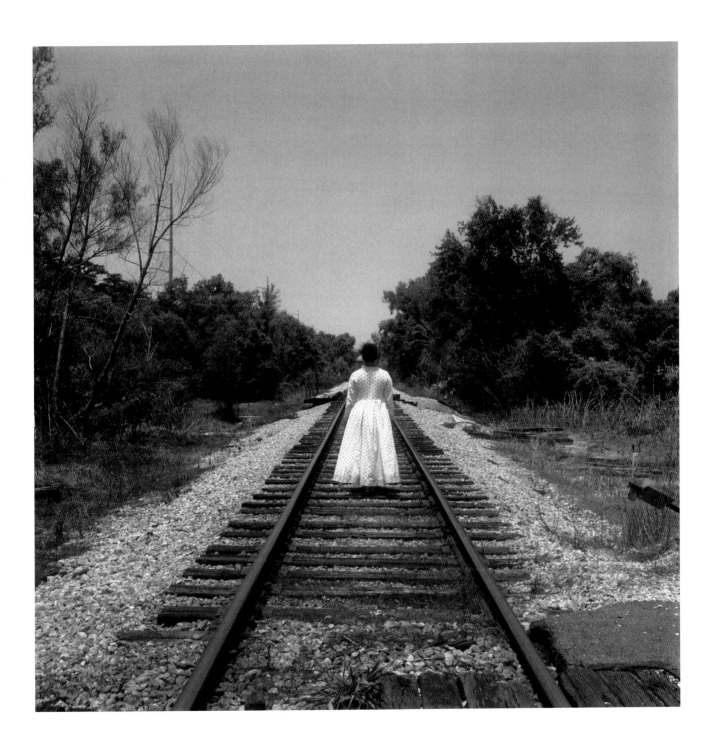

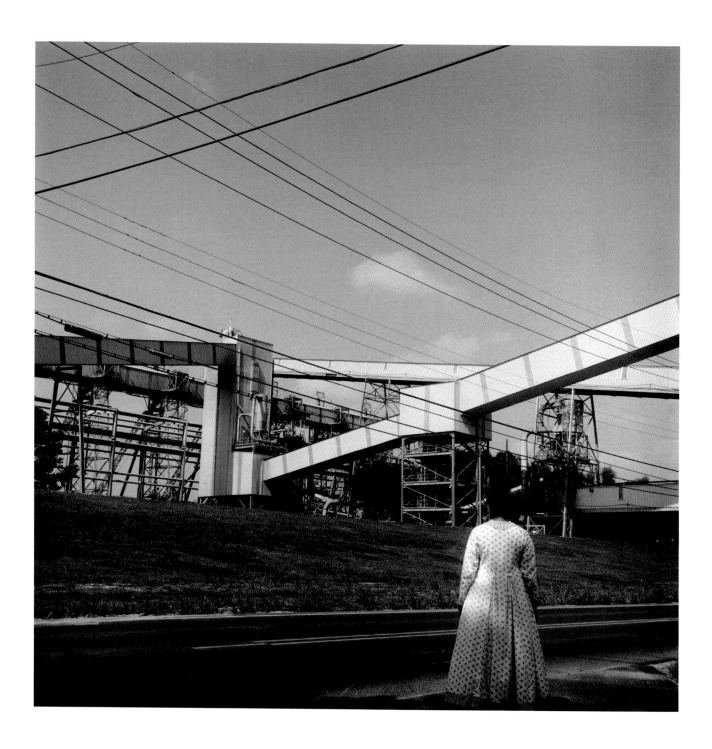

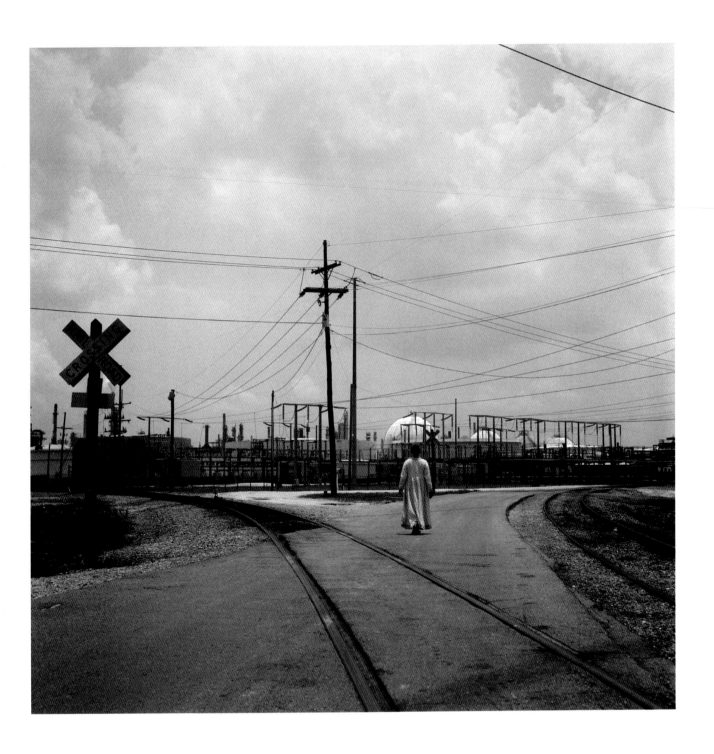

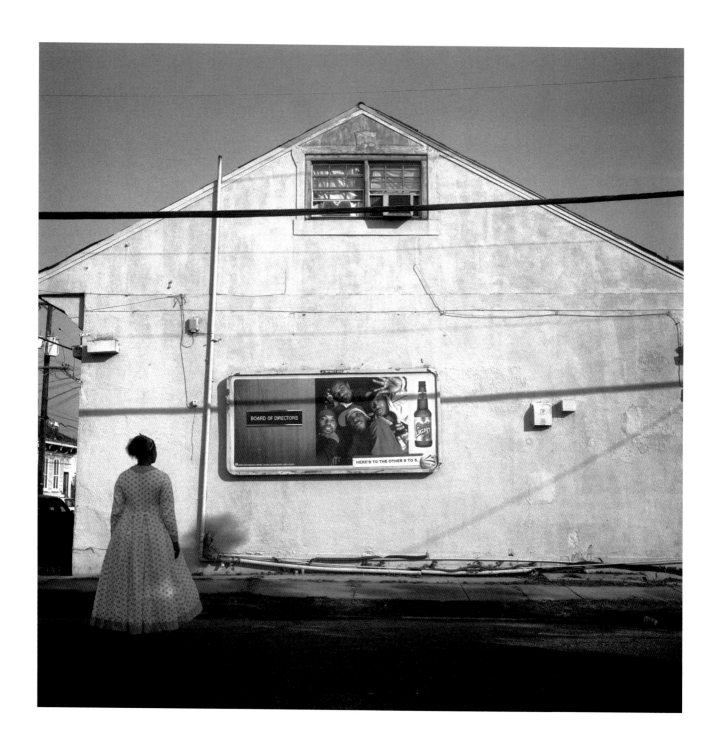

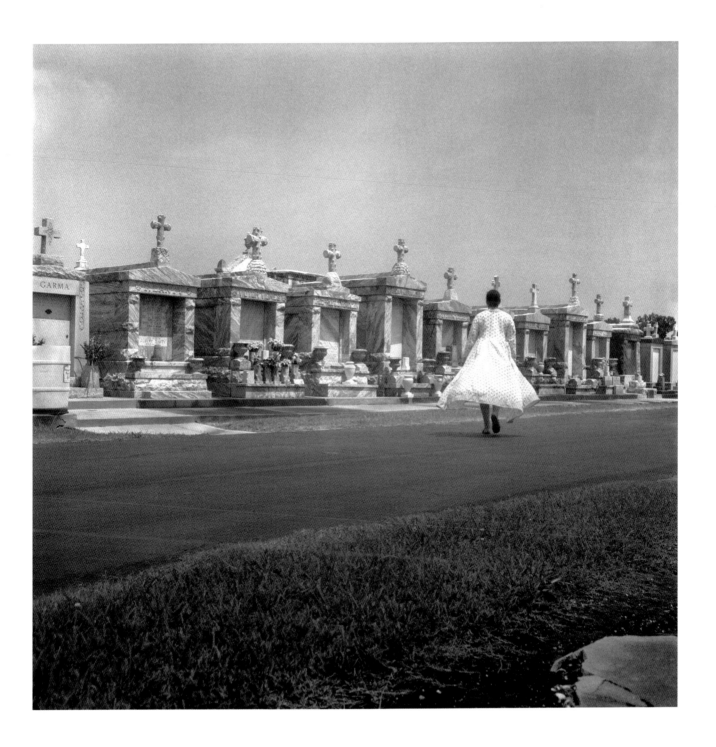

In 1873 in the midst of reconstruction, Comus mounted

"The Missing Links to Darwin's Origin of the Species." Following

the parade, The Daily Picayune *noted that Comus's gorilla*

was "a specimen, too, so amazingly like the broader-mouthed varieties

of our own citizens, so Ethiopian in his exuberant glee, so at home

in his pink shirt collar, so enraptured with himself and so fond of his

banjo, that the Darwinian chain wanted no more links."

JAMES GILL, *Lords of Misrule*

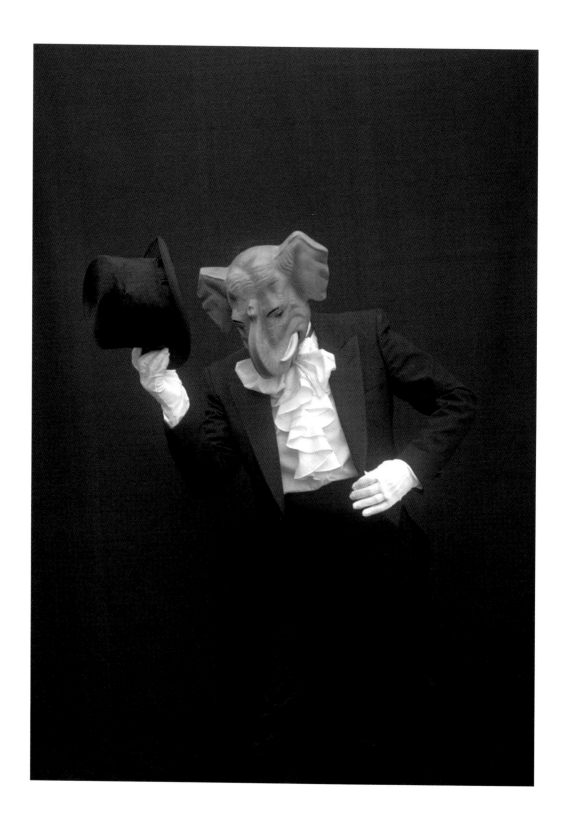

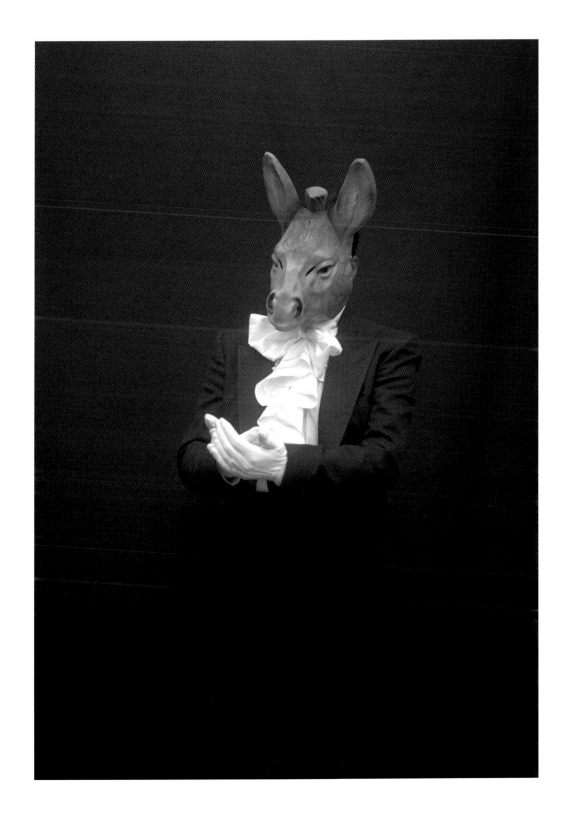

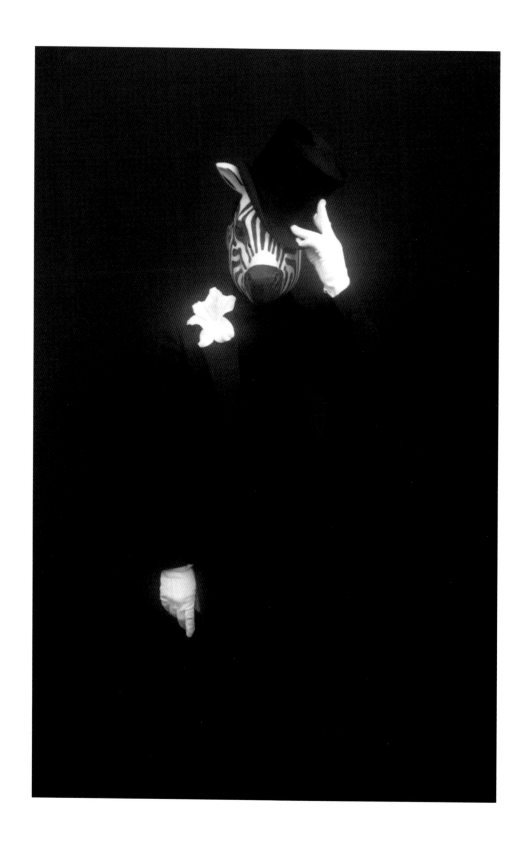

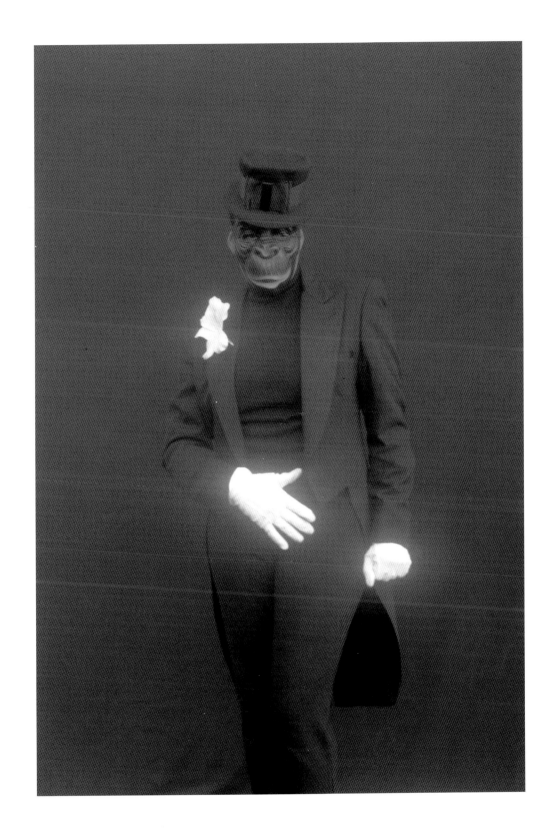

How can a wife still satisfy lust,

Since sin cannot be found in a wife's kiss?

Could Petrarch love his Laura as wife —

He never would have written a sonnet in his life.

LORD BYRON

THE SHADOW PLAY: MEANING AND LANDSCAPE

A woman illuminates the darkness; via the passage of time she leads us along the shores of the Mississippi, down the shadowy corridors and into the theater of history. It is here, in this dark place, that desire is found lazy and wanting. We were happy to be the playmates to the patriarch: men of power and wealth; after all, we were women.

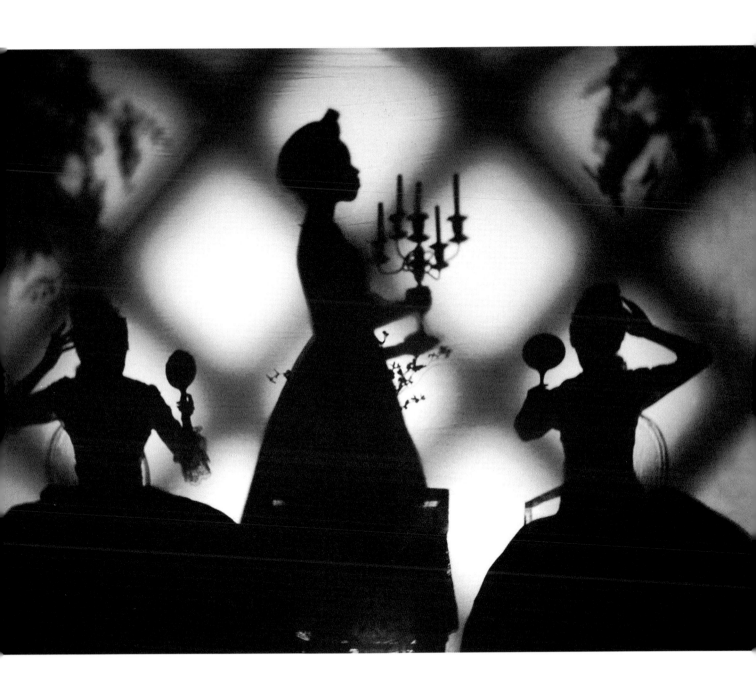

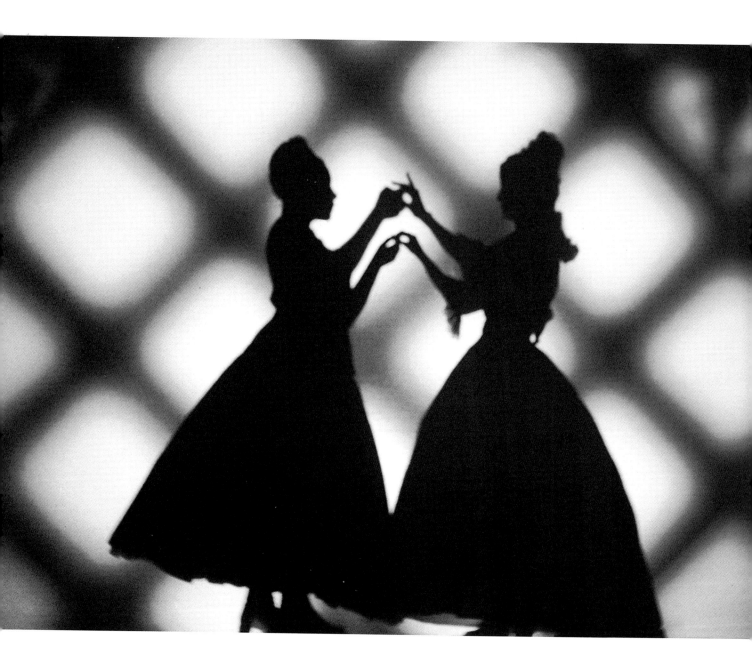

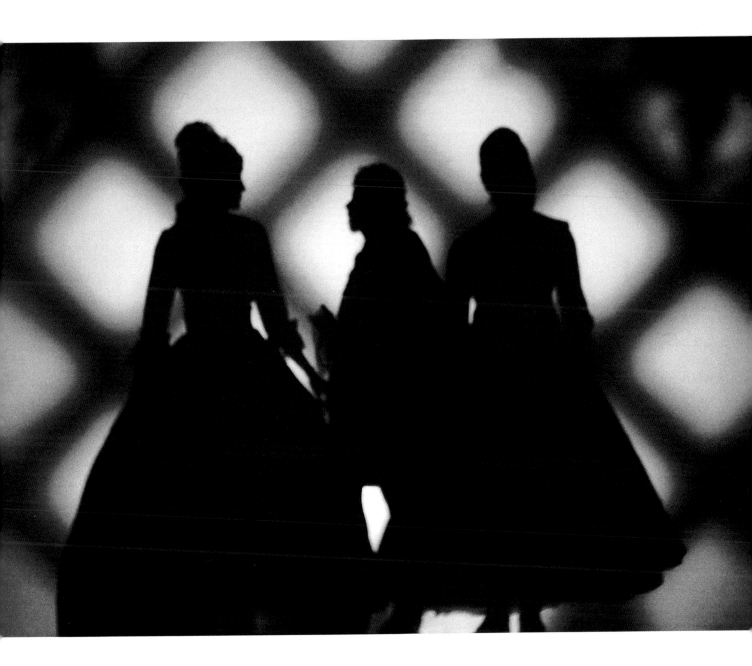

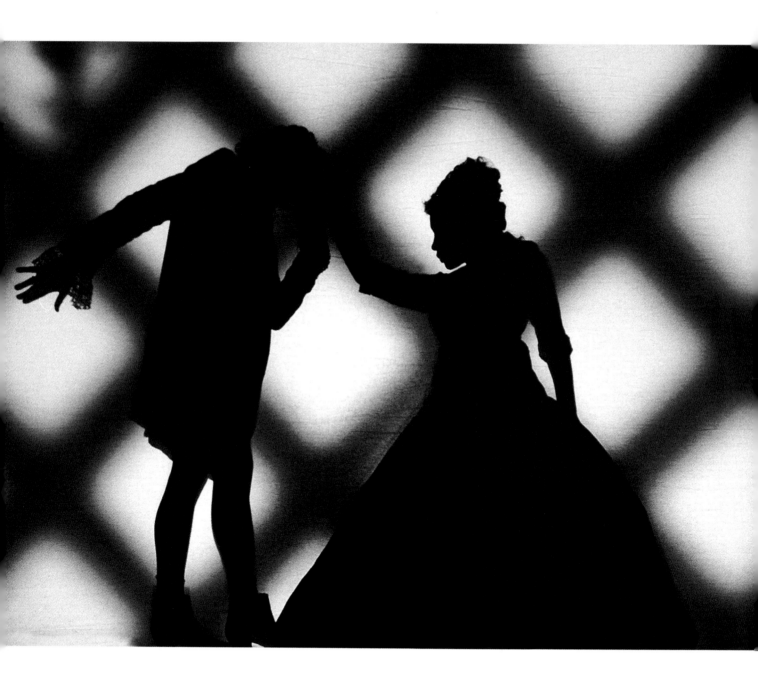

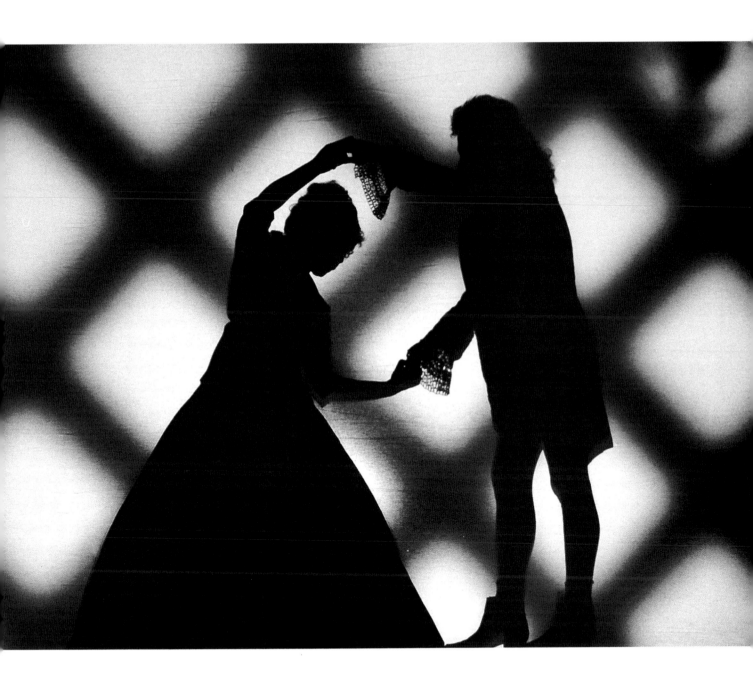

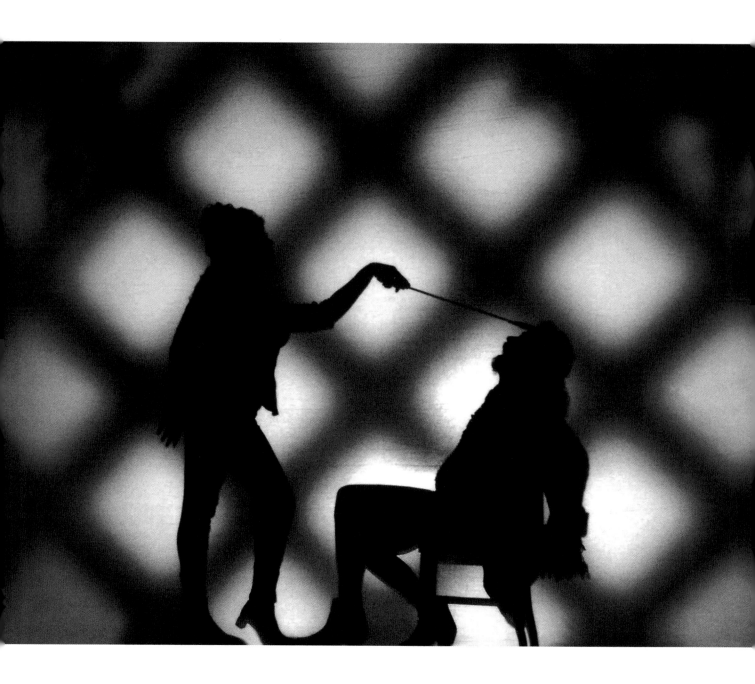

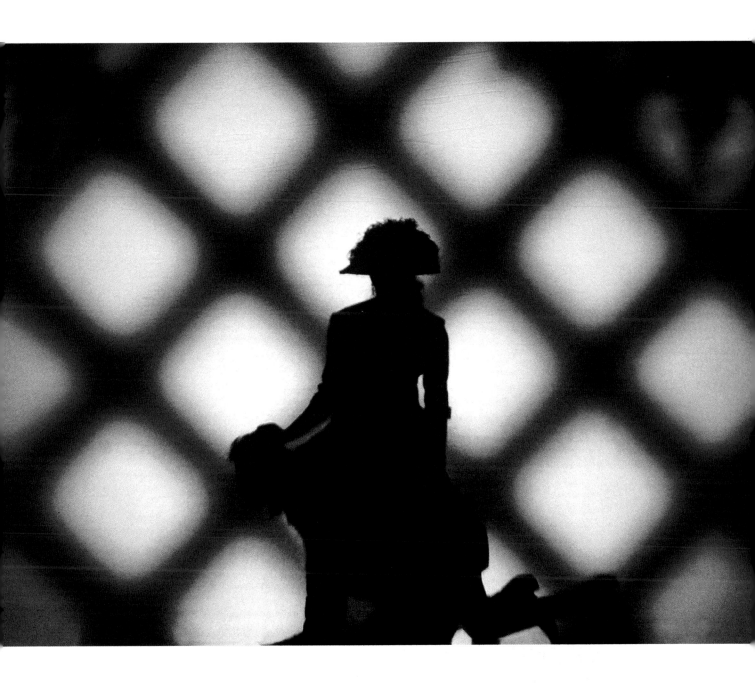

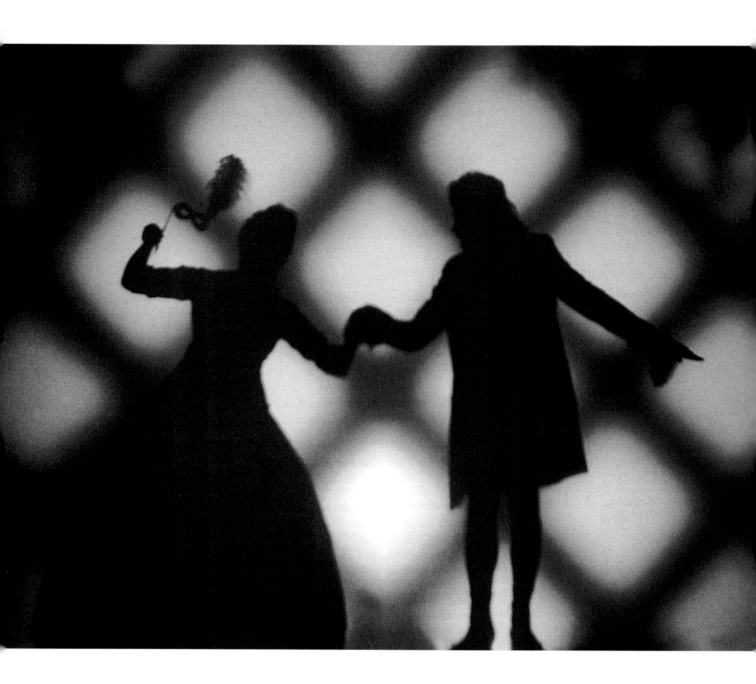

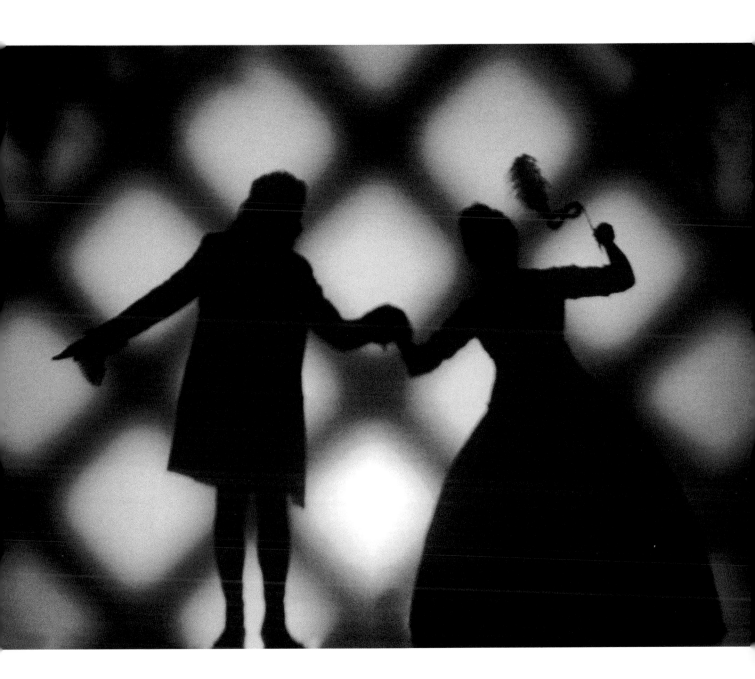

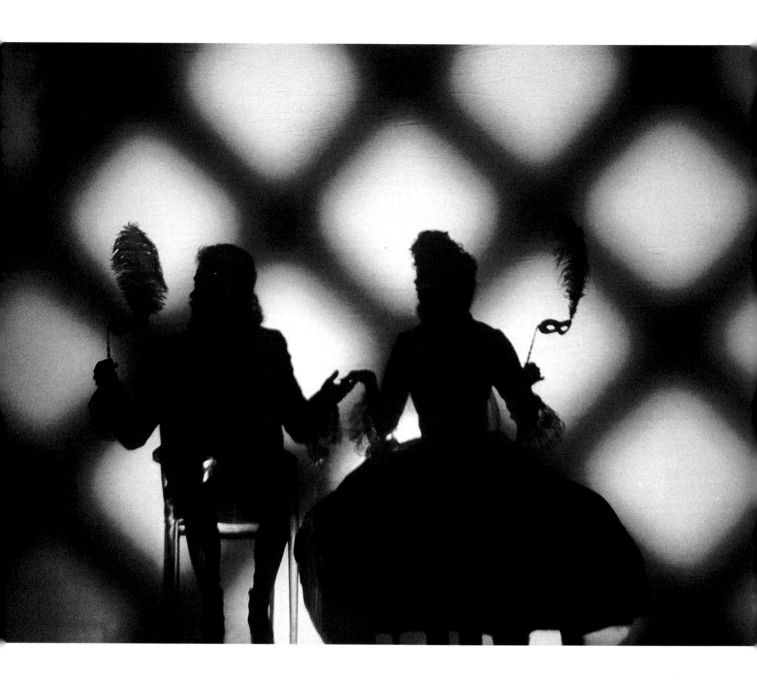

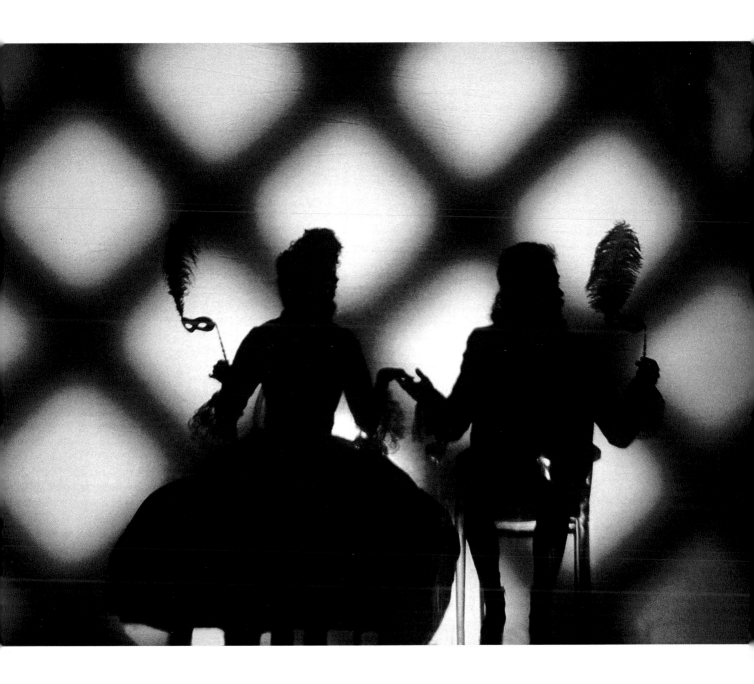

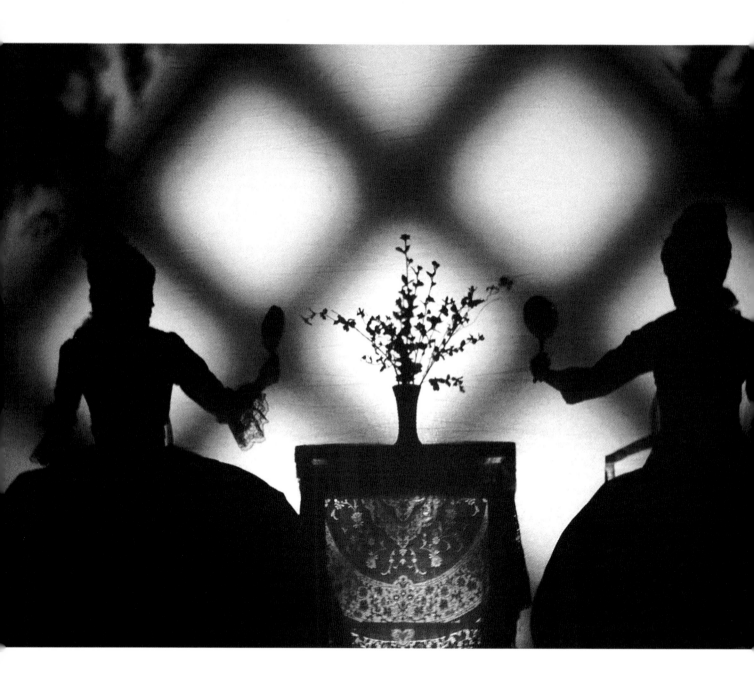

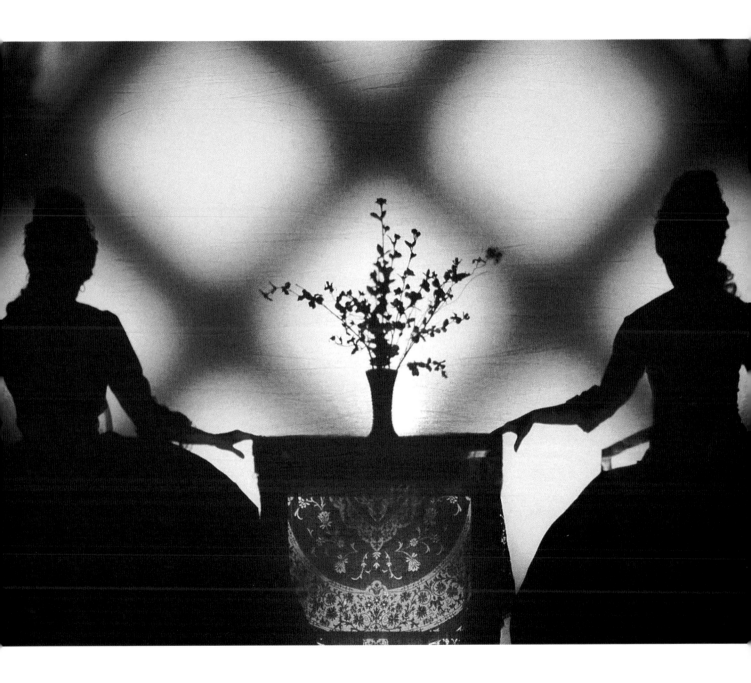

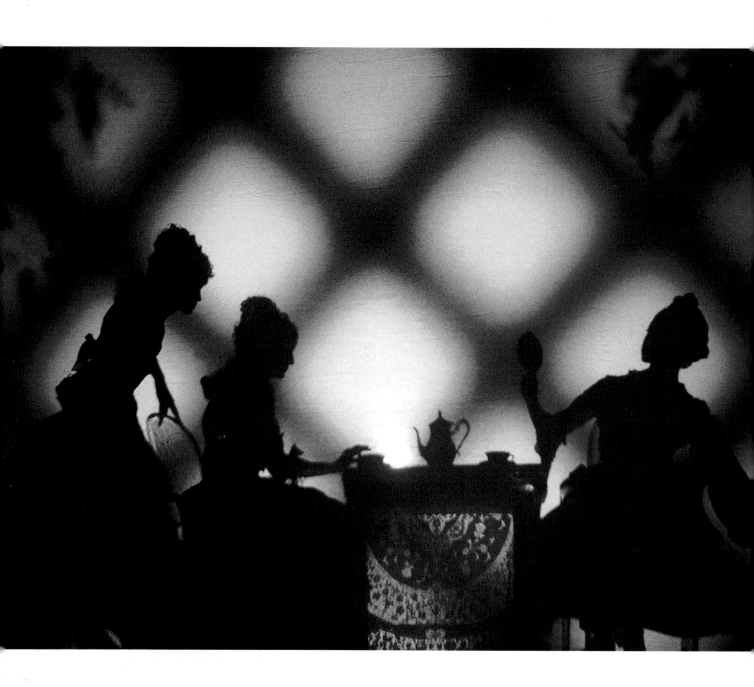

EXHIBITION CHECKLIST

6 PONDERING YOUR REMAINS
Ink on canvas, 84 x 84 in.

25 A LIKENESS OF NAPOLEON
C-print, 27$\frac{1}{2}$ x 23$\frac{1}{2}$ in. oval frame with convex glass.

25 AND A LIKENESS OF JEFFERSON
C-print, 27$\frac{1}{2}$ x 23$\frac{1}{2}$ in. oval frame with convex glass.

26 I LOOKED AND LOOKED
AND FAILED TO SEE WHAT
SO TERRIFIED YOU
C-print, 36$\frac{3}{8}$ x 24$\frac{3}{8}$ in. framed.
Panel 1 (face left) of a diptych.

27 I LOOKED AND LOOKED
AND FAILED TO SEE WHAT
SO TERRIFIED YOU
C-print, 36$\frac{3}{8}$ x 24$\frac{3}{8}$ in. framed.
Panel 2 (face right) of a diptych.

28 UNTITLED
C-print, 28$\frac{1}{8}$ x 28$\frac{1}{8}$ in. framed.
*Woman in pleated dress looking at own
reflection in mirror being held up to her.*

29 UNTITLED
C-print, 28$\frac{1}{8}$ x 28$\frac{1}{8}$ in. framed.
*Woman in 1890s period dress looking at own
reflection in mirror being held up to her.*

30 UNTITLED
C-print, 28$\frac{1}{8}$ x 28$\frac{1}{8}$ in. framed.
*Man looking at own reflection in mirror
being held up to him.*

31 UNTITLED
C-print, 28$\frac{1}{8}$ x 28$\frac{1}{8}$ in. framed.
*Woman in casual dress with sneakers looking
at own reflection in mirror being held up to her.*

33 A DISTANT VIEW
Iris print, 20$\frac{3}{4}$ x 20$\frac{3}{4}$ in. framed.

34 UNTITLED
Iris print, 20$\frac{3}{4}$ x 20$\frac{3}{4}$ in. framed.
*Woman walking along curved path towards
plantation house.*

35 APPROACHING TIME
Iris print, 20$\frac{3}{4}$ x 20$\frac{3}{4}$ in. framed.

36 A SINGLE'S WALTZ IN TIME
Iris print, 20$\frac{3}{4}$ x 20$\frac{3}{4}$ in. framed.
Panel 1 of a triptych.

37 A SINGLE'S WALTZ IN TIME
Iris print, 20$\frac{3}{4}$ x 20$\frac{3}{4}$ in. framed.
Panel 2 of a triptych.

38 A SINGLE'S WALTZ IN TIME
Iris print, 20$\frac{3}{4}$ x 20$\frac{3}{4}$ in. framed.
Panel 3 of a triptych.

39 SORROW'S BED
Iris print, 20$\frac{3}{4}$ x 20$\frac{3}{4}$ in. framed.

40 PASSAGEWAY I
Iris print, 20$\frac{3}{4}$ x 20$\frac{3}{4}$ in. framed.

41 PASSAGEWAY II
Iris print, 20$\frac{3}{4}$ x 20$\frac{3}{4}$ in. framed.

42 LOOKING FORWARD
Iris print, 20$\frac{3}{4}$ x 20$\frac{3}{4}$ in. framed.

43 LOOKING BACK
Iris print, 20$\frac{3}{4}$ x 20$\frac{3}{4}$ in. framed.

44 IN THE ABYSS
Iris print, 20$\frac{3}{4}$ x 20$\frac{3}{4}$ in. framed.

45 AT THE PRECIPICE
Iris print, 20$\frac{3}{4}$ x 20$\frac{3}{4}$ in. framed.

46 UNTITLED
Iris print, 20$\frac{3}{4}$ x 20$\frac{3}{4}$ in. framed.
Woman facing industrial tanks.

47 UNTITLED
Iris print, 20$\frac{3}{4}$ x 20$\frac{3}{4}$ in. framed.
Woman walking along railroad tracks.

48 UNTITLED
Iris print, 20$\frac{3}{4}$ x 20$\frac{3}{4}$ in. framed.
Woman facing industrial landscape.

49 UNTITLED
Iris print, 20$\frac{3}{4}$ x 20$\frac{3}{4}$ in. framed.
Woman facing railroad crossings.

50 UNTITLED
Iris print, 20³/₄ x 20³/₄ in. framed.
Woman standing before commercial billboard.

51 UNTITLED
Iris print, 20³/₄ x 20³/₄ in. framed.
Woman standing in cemetery.

54 MISSING LINK, JUSTICE
Iris print, 41¹/₄ x 29¹/₄ in. framed.

55 MISSING LINK, LIBERTY
Iris print, 41¹/₄ x 29¹/₄ in. framed.

56 MISSING LINK, HAPPINESS
Iris print, 41¹/₄ x 29¹/₄ in. framed.

57 MISSING LINK, DESPAIR
Iris print, 41¹/₄ x 29¹/₄ in. framed.

59 UNTITLED
Ink on canvas, 60 x 84 in.
Woman walking with candelabra.

60 UNTITLED
Ink on canvas, 60 x 84 in.
Two women dancing.

61 UNTITLED
Ink on canvas, 60 x 84 in.
Trio of guests at the ball.

62 UNTITLED
Ink on canvas, 60 x 84 in.
Man and woman greet each other at the ball.

63 UNTITLED
Ink on canvas, 60 x 84 in.
Couple dancing at the ball.

64 UNTITLED
Ink on canvas, 60 x 84 in.
Couple with riding crop.

65 UNTITLED
Ink on canvas, 60 x 84 in.
Woman as Napoleon riding atop a man.

66 UNTITLED
Ink on canvas, 60 x 84 in.
Couple dancing with mask, woman on left.

67 UNTITLED
Ink on canvas, 60 x 84 in.
Couple dancing with mask, woman on right.

68 UNTITLED
Ink on canvas, 60 x 84 in.
King (on left) and queen of Mardi Gras.

69 UNTITLED
Ink on canvas, 60 x 84 in.
Queen (on left) and king of Mardi Gras.

70 UNTITLED
Ink on canvas, 60 x 84 in.
Two women seated at small table,
each looking in a mirror.

71 UNTITLED
Ink on canvas, 60 x 84 in.
Two women seated at small table.

72 UNTITLED
Ink on canvas, 60 x 84 in.
Trio of women at small table,
one looking in a mirror.

ILLUSTRATIONS

INSTALLATION PHOTOGRAPHS
Susan Cahan, pages 8, 9, and 10

COIN DE LA RUE VALETTE TE
PANTHÉON, 5E ARRONDISSMENT,
MATINÉE DE MARS
Eugène Atget (1857-1927), page 13
1925. Albumen print (gold-toned), 7 x 9 in.
From the Collection of the The Museum of
Modern Art, New York. Licensed by SCALA/Art
Resource, New York.

FROM THE JEFFERSON SUITE
FROM THE KITCHEN TABLE SERIES
FROM DREAMING IN CUBA
Carrie Mae Weems, pages 12, 14, and 15
James Dee, photographer, page 12, top

ACKNOWLEDGMENTS

Even as a young artist I longed to work in Louisiana, to experience its complicated social history, to engage its fascinatingly dark cultural side, and make it the center of an artwork. Over the years, I made casual visits; always alone, wandering here and there, dropping in at archives, libraries, and bookshops, slowly gathering materials, documents, objects, taking notes, photographing, dreaming, and biding my time: awaiting the opportunity to work in New Orleans, Queen of the South.

The process of making a work of art, the time, energy, effort, commitment: I love, I need; I'm nothing without it. Like Blanche DuBois, who presided in the shadows of time, I've come to depend upon the kindness of strangers, my colleagues, and my friends, without whom there would be no *Louisiana Project*.

Several people—many behind the scenes—helped with this project: beginning with Tulane University friends, professors, and students; artists-actors Harry Freeman Jones, Jeri Nelson, and Soon-Mi Yoo; videographer Wook Steven Heo; and editor Robert Chang Chin Lin.

I am especially indebted to my insightful friend Joyce Menschel, who shared her early experiences at Newcomb College; my assistant Pamela Vander Zwan; designer Tana Coman; art history professor and Newcomb Art Gallery director Erik Neil, who guided me through the psychological labyrinth of New Orleans and welcomed me into the midst of his lovely family, where I found substance and sustenance; and, lastly, to my husband, Jeffrey Hoone, whose tender embrace shelters me from the storm.

—*Carrie Mae Weems*

This exhibition and publication were made possible in part through the generous support of the Horace W. Goldsmith Foundation.

Among the many individuals who made this project possible it is especially important to acknowledge the efforts and support of Joyce Frank Menschel, Sandra and Richard Freeman, Mignon Faget, Pamela Franco, Sally Main, Pamela Vander Zwan, Pamela Auchincloss, Gary van Zante, Stacy LaFleur, William Fagaly, and, above all, Carrie Mae Weems.

—*Erik H. Neil*

Design: Tana Coman Editing: Mary Ann Travis